RICHARD I'ANSON

D0615888

URBAN
TRAVEL PHOTOGRAPHY

778-9

1- Urban photography
2 Photography — Technique
I. t

LONELY PLANET OFFICES

AUSTRALIA

Head Office
Locked Bag 1, Footscray, Victoria 3011
☎ 03 8379 8000, fax 03 8379 8111
talk2us@lonelyplanet.com.au

UK

72–82 Rosebery Ave,
Clerkenwell, London EC1R 4RW
☎ 020 7841 9000, fax 020 7841 9001
go@lonelyplanet.co.uk

USA

150 Linden St, Oakland, CA 94607
☎ 510 893 8555, toll free 800 275 8555
fax 510 893 8572, info@lonelyplanet.com

Urban Photography: A Guide to Taking Better Pictures
1st edition June 2006
ISBN 1 74059 540 8

Published by Lonely Planet Publications Pty Ltd
ABN 36 005 607 983

text © Lonely Planet 2006
photographs © Richard I'Anson 2006

Cover photograph: Eiffel Tower detail, Paris, France

LONELY PLANET IMAGES All images in this guide are available for licensing from
Lonely Planet Images: www.lonelyplanetimages.com.

CONTENTS

THE AUTHOR

Richard I'Anson is a Melbourne-based travel, landscape and stock photographer. He travels regularly photographing people and places for clients, books and his stock collection.

Richard received his first camera as a gift from his parents when he was 16 and hasn't stopped taking photographs since. After studying photography, film and television for two years at Rusden State College in Melbourne, he worked in a camera store and minilab before going freelance in 1982. His work has been widely published in books, magazines, brochures and calendars, and has been exhibited in both solo and group exhibitions. In 1998 he published his first book, *Chasing Rickshaws*, a collaboration with Lonely Planet co-founder Tony Wheeler. In 2000 he published *Travel Photography: A Guide to Taking Better Pictures*. Richard and Tony's second collaboration, *Rice Trails: A Journey through the Ricelands of Asia and Australia*, was published in 2004, as was the second edition of *Travel Photography*.

To establish himself in this niche area of photography, Richard travelled for almost three years between 1986 and 1990 in Asia. He has won several Australian Institute of Professional Photography awards and in 1996 achieved the level of Master of Photography.

Lonely Planet has been using Richard's photographs for 16 years and his work has been featured in over 300 editions of LP titles. He is also the founder of Lonely Planet Images, Lonely Planet's commercial stock agency. You can see more of his work at www.richardianson.com and www.lonelyplanetimages.com.

THIS BOOK

From the Publisher

This book was produced in Lonely Planet's Melbourne office. It was commissioned by Bridget Blair, and Jenny Bilos managed the project with assistance from Jo Vraca. Adrienne Costanzo and Martine Lleonart edited the book, which was designed by Brendan Dempsey and laid out by Jim Hsu. Mark Adams designed the cover artwork and Ryan Evans managed pre-press preparation of the photographs.

Using This Book

Urban Photography introduces you to the wide range of subject matter that you'll encounter in any city, big or small, anywhere in the world. It aims to lift your travel photography to the next level of creativity with practical advice, tried and tested tips and inspirational images sure to get you thinking about both your photography and your next trip.

This book is not for the absolute beginner. It assumes you're using or aspiring to use a single-lens reflex camera (SLR; film or digital) and are striving for the highest-quality image. It assumes that you know your shutter speed from your aperture, RAW files from JPEGs, that you can use your camera in semiautomatic mode and that you're keen to delve deeper into a specific subject area on your photographic journey. It also assumes that photography is given a high priority when you do travel.

Having said that, the principles and advice discussed for improving technique and achieving creative results can be understood and applied by anyone interested in improving their photography, no matter what equipment is used.

Although this book is packed with images taken in cities all over the world, you don't have to have a trip planned for it to be useful. Get out there and put the tips and techniques to the test in your own city. Urban environments are exciting places to be and your photography should reflect that. This book will help you achieve that goal.

The Author's Approach

I've had the privilege of photographing many of the world's great cities and just as many lesser-known ones as well, although the list of places to visit is still a lot longer than the list of places I've been. Even after all these years the thrill of landing in a new city, dropping the bags at the hotel, grabbing the camera and hitting the streets hasn't waned. In fact, I enjoy it more now because I'm confident I'll be able to deliver the pictures I've come to take.

Photographing in the urban environment is an intense, exciting, tiring and thoroughly rewarding photographic endeavour. I probably walk 10km to 15km a day, shoot between 300 and 400 frames and get very little sleep. But by the end of my stay I'll have a comprehensive collection of images that capture a good cross section of the places to see, things to do and the people who live there.

I keep my gear as simple as possible, but to cover the range of subjects I know I'll encounter and to work as fast and as efficiently as possible I always carry two SLR cameras, one with a 24–70mm lens and the other with an 80–200mm lens (see the list below). I only take the tripod, 300mm lens and flash unit for specific shots. The X-Pan camera usually stays locked up in the hotel room in case everything else is stolen.

I take the same gear on every city-based trip. I prefer to use available light (daylight or incandescent) no matter how low, and always use fine-grain films. My standard outfit consists of the following:

▶ two Canon EOS 1v SLR camera bodies, one with Power Drive Booster E1
▶ two Canon EF zoom lenses: 24–70mm f2.8 L USM and a 80–200mm f2.8 L USM image stabiliser
▶ a Canon 300mm f2.8 L USM lens
▶ a Canon 1.4x teleconverter
▶ a Hasselblad X-Pan 35mm panoramic camera with 45mm f4 lens; I don't use it a lot but it's an excellent backup camera and easy to carry if the big 35mm gear isn't required
▶ a Gitzo G1228 carbon-fibre tripod with Fobar Superball head; I photograph skylines, city views, low-light street scenes and some interiors on the tripod, but everything else is hand-held
▶ a Canon 420EX flash unit
▶ a Lowepro Street and Field Reporter 400 AW soft shoulder bag, which holds everything, except the tripod and 300mm lens

All the gear, including film but not including the tripod, is carried onto the plane in a Lowepro Street and Field Rover Light backpack. I then transfer what I need into a Lowepro Street and Field Reporter 400 AW soft shoulder bag when I'm out taking photos.

In Australia (where I live), and very occasionally on overseas assignments, I use a medium-format system consisting of the following:

▶ a Mamiya 7ii 6 x 7cm rangefinder camera (always mounted on a tripod)
▶ 50mm f4.5 and 150mm f4.5 lenses

I use circular polarising filters (see p19) and, of course, a skylight filter on every lens. My preferred film is Kodak Ektachrome E100VS. For extra speed I switch to Kodak Ektachrome E200, which I rate at 800 ISO.

Digital images in this book were taken on a Kodak Professional DCS ProSLR/c camera.

Photo Captions

The photographs and captions in this book are provided to help you learn about taking photos in a variety of circumstances. They include the following information:

▶ camera, lens and film or file size (note that some films are not available any more or are known by a different name in other countries)
▶ shutter speed and aperture
▶ tripod, filters and flash, if used

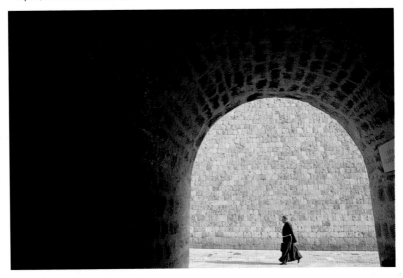

Priest on Placa, Dubrovnik, Croatia

When you find a great location and the light is just right but an element beyond your control is needed to make the picture – such as a priest walking past – you'll have to balance the competing desires of trying to see everything in the city and patiently waiting for the perfect moment to create interesting pictures. Always wait – you can run to catch up afterwards.

▲ 35mm SLR, 24-70mm lens, 1/125 f8, Ektachrome E100VS

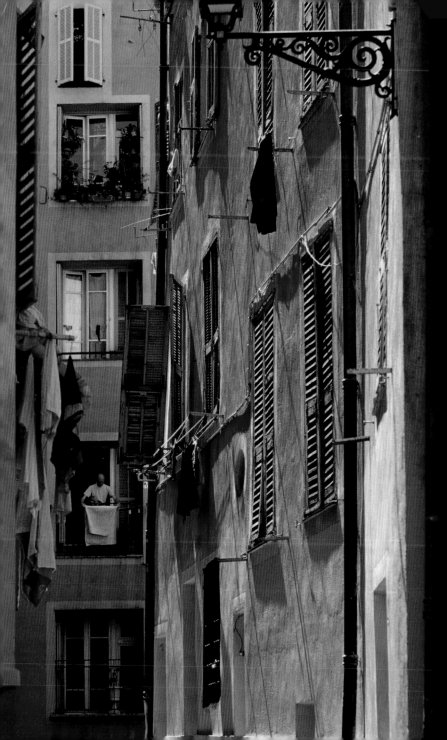

INTRODUCTION

If you're taking pictures in a city or town you're engaged in urban photography. It doesn't matter how big or small the place is or what you're photographing – buildings, people, parks or a band playing in a bar – you'll be shooting urban pictures in an urban environment.

For the photographer who likes to shoot a wide range of subjects this is great news. The urban environment of the world's towns and cities provides easy access to the greatest variety of subject matter and photographic possibilities per square kilometre than any other photographic genre in any other location. In the time it takes to walk a block or two, you can photograph panoramic skylines; people up close, at work or at play; abstract architectural details; frenetic street activity; and peaceful park scenes. You can capture elements of the past and the present through the city's architecture in one carefully composed street scene, focus in on torn wall posters in a dimly lit alleyway and within minutes be framing up the most recognisable landmark in the city.

For the majority of us this environment is on our doorstep, as most of us live in, or close to, cities and towns. In fact, you could photograph your own doorstep in pursuit of an urban image. This means you can get out there and shoot urban pictures every day, even if you don't have a trip planned to an exciting megalopolis.

If you do have a trip planned, be warned. Arrive in a new city intent on covering the full range of subjects the urban environment has to offer and you'll find you won't have much time between shots and little time to rest. Cities and towns are rich in subject matter and offer round-the-clock photo opportunities. A typical day will look like this:

▶ up before dawn to get to a predetermined location before the sun rises to capture the classic skyline or city view at first light
▶ over to the waterfront for early-morning activity
▶ into the city centre for people- and traffic-free architectural pictures of key buildings and quiet streetscapes as the city wakes up
▶ head to the morning produce markets for an hour or so
▶ back to the main thoroughfares and city squares as peak-hour crowds and traffic build up for busy streetscapes
▶ breakfast and note taking
▶ walk the streets searching out new views, urban details, interesting shops and people engaged in daily activities
▶ a late-morning visit to the city's museums and art galleries
▶ get to an outdoor-eating precinct in the middle of the day as cafés fill with lunchtime crowds
▶ lunch and note taking
▶ an early-afternoon walk around shopping precincts before visiting places further from the city centre, including parklands and beaches
▶ mid-afternoon check out the craft markets and city squares to photograph souvenir stalls, street performers and people shopping
▶ then take a quick walk around the food-market precinct as the cafés and bars get busy
▶ late afternoon head to a vantage point for another (and different) city skyline or view
▶ stay on at the viewpoint to photograph the skyline at dusk as the lights take effect or dash to another location to photograph a key building or streetscape in the half-hour after sunset
▶ dinner and note taking
▶ spend the evening in the night markets, photographing bands playing in bars and people dancing in nightclubs – by now it's gone midnight and you've got to get up and do it all again in around five hours

Hanging washing on balcony, Nice, France
◀ 35mm SLR, 80-200mm lens, 1/250 f8, Ektachrome E100VS

Although this schedule suggests a frenetic pace to see and photograph everything, the aim is to create a series of images that capture the character and diversity of a place and to photograph all subjects in the best possible light. When time is limited there will clearly be a tension between seeing everything and taking quality images. This tension is increased when you realise that cities are dynamic and that things can change dramatically within minutes. To really get to know a city you have to be prepared to retrace your steps over and over again at different times of the day on different days of the week. A quiet Sunday market can become a busy throng as people pour out of a nearby church after the service finishes. Crowds gather and disperse as street entertainers come and go. Restaurant and bar precincts humming at midnight are deserted at nine in the morning. Parks that are empty on weekdays become the focus of activity on weekends, while busy business districts are abandoned.

While all urban environments have much in common, the challenge for the photographer is to reveal the unique spirit of each city. Many cities are famous for certain buildings, skylines or activities and until people visit that is often all they know about the place. As a photographer you should aim to delve much deeper to reveal a more realistic and comprehensive impression of each city. Sure, you'll want to include the famous sights, but aim to capture images of every city or town you visit that will surprise, inform and intrigue your viewers.

Girl eating ice cream, Cuzco, Peru
35mm SLR, 24mm lens, 1/60 f5.6, Kodachrome 200 ▶

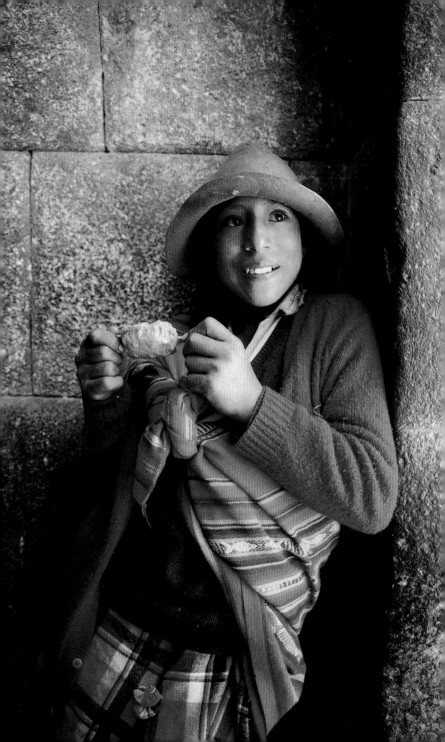

PART ONE

THE GEAR

Choice of equipment is important. It's the first building block in a series of creative decisions you'll make that lead to capturing images that reflect your personal photographic vision. A good photographer can take good pictures of any subject on any camera with any lens; however, matching your gear to the kinds of shots you want to take makes photography more enjoyable and more productive.

Skyscraper façades in Central, Hong Kong, China
◄ 6 x 7cm SLR, 105mm lens, 1/30 f8, Ektachrome 100STZ, tripod

EQUIPMENT

You can expect to be out and about for many hours at a time, walking, watching and waiting for that great shot, so unless you have very specific aims that demand a truckload of specialist equipment, keep your gear to a minimum. A pack with a couple of camera bodies and three lenses might not feel particularly heavy when you pick it up at home to put it in the car, but after a couple of hours on your shoulder, it can become so burdensome that it acts as a real disincentive to walk an extra kilometre or climb those extra steps. Your gear shouldn't be a reason for not getting to the places and getting the shots you bought it for in the first place.

When you're out taking photos, aim to fit everything you need comfortably into a small- to medium-sized shoulder bag that allows quick access and doesn't cause you to walk around with an obvious lean. Other gear can be taken on the journey for specific shots but left in the hotel room until required. A tripod, for example, is useful for capturing some images, but there is no need to carry it around with you all day.

Experience and an understanding of your photographic goals will help you decide what equipment is right for you, but a good starting point, given the breadth of subject matter you'll encounter in an urban setting, is a 35mm film or digital single-lens reflex (SLR/DSLR) camera body with a couple of lenses. Two zooms, such as a 24–90mm and 80–200mm, will cover most subjects. If you'd prefer to carry only one lens, a zoom with a focal-length range around 24–135mm is the best option. Note that these focal-length recommendations are based on 35mm film or full-frame digital sensors. For other digital cameras seek out the equivalent focal lengths to suit the size of your sensor. Add a compact flash and a lightweight tripod and you'll be able to deal with most subjects and most situations.

Old city, Lijiang, China
Choose equipment that suits the kinds of pictures you want to take. Some photographers take all their pictures on a panoramic camera; I use it as my backup in case my first-choice gear is stolen, lost or breaks down. I do enjoy using it though, when the subject matter is ideally suited to the panoramic format.
▲ 35mm Rangefinder, 45mm lens, 1/30 f16, Ektachrome E100VS, tripod

Boy asleep at temple entrance, Ho Chi Minh City, Vietnam
◀ 35mm SLR, 24mm lens, 1/30 f5.6, Kodachrome 200

CAMERAS

Given the ever-expanding range of camera models available, the quickest way to narrow down your options is to decide why you're taking the photos and what you want to do with them. Medium-format and panoramic cameras are used by professionals to shoot urban subjects, especially skylines and architecture, but for travellers the choice really comes down to film or digital SLR cameras, advanced compact digital or more specialist rangefinder cameras.

Single-Lens Reflex Cameras – Film & Digital

For the traveller intent on serious photography and aiming for success across the widest range of subjects in all situations, a film or digital SLR remains the camera of choice. The SLR's versatility, sheer number of useful features and ability to take interchangeable lenses to suit all subjects makes it the ideal travel camera. There are also models to suit all budgets. Switch them on to auto mode to avoid worrying about the technical stuff or use the manual override to take control of the technical side of photography if you choose.

The main drawback of the better-quality models and the accompanying lens range is that they can be heavy and bulky when compared to compact or rangefinder cameras. But that's a small price to pay if you're intent on getting great pictures.

Advanced Compact Digital Cameras

If you're prepared to sacrifice the advantages of an SLR to minimise weight and bulk, an advanced compact digital camera is the next best option. Available with 4 MP to 8 MP sensors, the best of these cameras are well built and packed with features, including high-quality zoom lenses; large, bright LCD screens; manual exposure modes; and multipoint autofocus sensors to handle off-centre subjects.

Rangefinder Cameras

These cameras, available in film and limited digital models, are aimed at the professional and keen enthusiast. They're popular with photojournalists and street photographers because they're compact and virtually silent, and there's no viewfinder blackout at the moment of exposure, so it's much easier to work discreetly than with an SLR or DSLR. However, they don't have a huge following as they lack the advanced features, sophisticated metering and lens range of SLRs. Still, check them out if you intend to specialise in candid people photography and want traditional film results with minimum weight and bulk.

LENSES FOR SLR CAMERAS

You can photograph any subject with any lens as long as you can get close enough or far enough away and, thanks to the plethora of subject matter in the urban environment, good use can be found for all focal-length lenses. However, given the aim is to keep the gear simple and manageable, a couple of quality zoom lenses will cover most needs.

Don't compromise on lens quality as it determines image sharpness, colour and the light-gathering capacity of the lens, which can determine how you shoot in various lighting conditions. If you're on a tight budget, go for a camera with fewer features and buy the best lenses you can afford.

Another feature available on some lenses, and well worth paying for, is image stabilisation (IS). This technology counteracts camera shake and allows the lens to be hand-held at shutter speeds two or three steps slower than required for non-IS lenses. For example, with a 200mm lens IS technology allows hand-held photography at 1/60 or even 1/30 of a second, rather

than the recommended 1/250 of a second for non-IS lenses. This means images can be taken in lower light without a tripod or without switching to a faster ISO film or sensor setting.

Note that the following references to focal length are based on 35mm film or full-frame digital sensors. For other digital cameras seek out the equivalent focal lengths to suit the size of your sensor.

Wide-Angle Lenses

Wide-angle lenses range from the super-wide focal lengths of 17–24mm to the more common 28mm and 35mm focal lengths. With their very wide angle of view, the super-wide-angle lenses lend themselves to panoramic city views, and are essential for getting entire buildings in frame when there is a limited distance you can get back from the building. They are also ideal for shooting the interiors of shops, museums and galleries. The 24mm is useful for photographing people in their environment. The 28mm and 35mm focal lengths are often used by photographers as standard lenses because they produce pictures with a natural perspective but take in a considerably wider angle of view than do standard lenses.

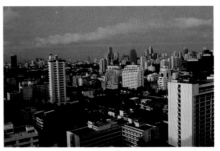

▲ 35mm SLR, 24-70mm lens at 24mm, 1/80 f11, Ektachrome E100VS, tripod

Standard Lenses

Standard lenses have focal lengths of 50mm or 55mm, which have an angle of view that is close to what the eye sees. Before zoom lenses became the norm, SLRs were commonly sold with a 50mm f1.8 lens. Standard lenses still have an important place, as they're compact, light and are the fastest lenses available, making them ideal for low-light photography.

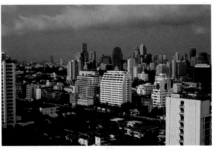

▲ 35mm SLR, 24-70mm lens at 50mm, 1/80 f11, Ektachrome E100VS, tripod

Telephoto Lenses

In the telephoto range the most useful lenses are those with a focal length around 85mm to 105mm, as they are ideal for photographing streetscapes, portraits and details. Longer telephoto lenses with focal lengths that range from 135mm to 250mm are suited to picking faces out of a crowd, architectural details, festivals and sporting events.

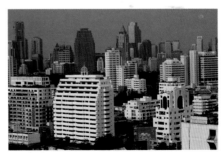

▲ 35mm SLR, 24-70mm lens at 200mm, 1/80 f11, Ektachrome E100VS, tripod

Sukhumvit district, Bangkok, Thailand
The advantage of carrying various focal-length lenses, either fixed prime lenses (with a fixed focal length) or zooms, is clear when you can take three different pictures without leaving your hotel room.

Zoom Lenses

Zoom lenses are the ideal choice for the travelling photographer. Not only do they cover the range of several fixed-focal-length lenses, but they also give you access to all the focal lengths in between. The main drawback with zoom lenses is that they're slower than comparable fixed-focal-length lenses. This often results in pictures that are not sharp as a result of camera shake. This is especially the case at the telephoto end of the zoom range and when using the close-focusing feature. Most new cameras aimed at the consumer market are packaged with a zoom lens at the cheaper end of the price range to keep the cost down.

Perspective-Correction Lenses

Perspective-correction (PC), or tilt and shift, lenses are used by architectural photographers to eliminate the linear distortion that occurs when you tilt a camera up to photograph a building.

These specialist and very expensive wide-angle lenses allow control of the angle of the plane of focus through tilt and shift movements so that you can keep the film plane parallel to the building. These will only be of interest to travellers with a special interest in architecture or those of you who just can't stand the look of buildings that appear to be falling backwards. Keep in mind that converging verticals can now be manipulated in image-editing software such as Photoshop.

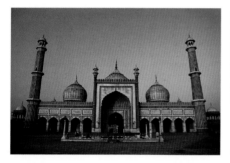

Jama Masjid, Old Delhi, India

The minarets aren't about to fall over backwards, but that's the impression you'll get when you point your lens up at a building. Perspective-correction lenses are the professional way to photograph buildings without having to find a vantage point that allows you to keep your film or sensor plane parallel with the subject (see p67).

◀ 35mm SLR, 24mm lens, 1/60 f8, Ektachrome E100SW

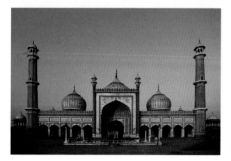

◀ 35mm SLR, 24mm lens, 1/60 f8, Ektachrome E100SW, corrected in Photoshop

FILTERS

You don't need many filters in an urban setting, especially if you're shooting digitally, as the white-balance function on digital cameras overcomes many of the problems that filters are used to alleviate. If you want to keep your gear simple, only two filters – a skylight and polariser – are necessary if you're using colour film or a digital sensor.

Every lens in your bag should have a skylight (1B) or UV filter screwed to the front to protect it from dirt, dust, water and fingerprints.

A polarising (PL) filter will eliminate unwanted reflections by cutting down the light reflected from the subject. This increases the colour saturation and the contrast between different elements in the image. In the city this is most useful when photographing sky-lines and reflections in the glass of skyscrapers or shop windows and for cutting down glare on statues and street art such as murals. There are two types of polarising filters: the standard PL and the circular polariser (PL-CIR). The PL-CIR is designed to avoid problems with TTL (Through the Lens) autofocusing. Check your camera manual, but if in doubt, use a circular polariser.

If you're shooting a lot of interiors on film and you want to record the colours faithfully, you should carry an 82 series colour-conversion filter. Most interiors are lit predominantly with incandescent light, which records as a yellow orange colour cast on standard film balanced for daylight. The colour and strength of the cast depends on the type and mix of artificial lights. This cast may render the colours inaccurately, but it creates ambience and shows that it was taken indoors. Alternatively, you could use tungsten film, which is balanced for incandescent light and renders colours as if you were shooting in natural light.

Shop window, Hong Kong, China
Without a polarising filter, the reflections from the window detract from the subject, reducing contrast and colour.

▲ 35mm SLR, 24mm lens, 1/30 f5.6, Kodachrome 200

Shop window, Hong Kong, China
Use a polarising filter and reflections are minimised, colour saturation and contrast are retained and a much better image results.

▲ 35mm SLR, 24mm lens, 1/30 f2.8, Kodachrome 200, polarising filter

TRIPODS

You'll be able to photograph most subjects without the aid of a tripod or other camera support, but you won't necessarily be able to take the best photographs. If you want to use fine-grain films or minimise noise from your digital camera sensor in low light, indoors or out, maximise depth of field and use slow shutter speeds for creative effects, a tripod is needed. You can try to get away with other camera-support solutions such as tiny table-top tripods, walls, piles of stones or your camera bag, but when speed, flexibility and guaranteed results are of the essence nothing beats a sturdy tripod with a ball head and a quick-release plate.

Harbour & pier at sunrise, Geelong, Australia

Carrying a tripod can be a real hassle, but when the light is low, the colours saturated and you want the finest detail in your pictures they're an essential piece of gear.

◀ 35mm SLR, 100mm lens, 1/8 f16, Ektachrome E100SW, tripod

FLASH UNITS

Available light is the primary source of illumination for travel photographs but it still pays to carry a compact flash unit (also called flashguns or speedlights). There will be times when it's inconvenient, impractical, prohibited or simply too dark (even for fast films and quality sensors) to set up a tripod. You'll also find flashlight particularly useful in nightclubs, bars and restaurants where it's best used in conjunction with the available light to retain the venue's atmosphere.

The majority of new cameras have built-in flash units and while these provide a convenient light source that is ideal for candid photos in restaurants and at parties, they have limited value for creative photography. Remember to always work within the power range of your flash unit. Most will illuminate subjects that are between 1m and 5m from the flash.

ACCESSORIES

Once you've got your equipment organised, you'll need a convenient and practical way of carrying it, as well as a few other bits and pieces to ensure things go smoothly on the road. Assuming you'll need regular and quick access to your gear, a soft shoulder bag with a wide strap is the way to go, rather than a day-pack, which is great for carrying lots of equipment but inconvenient to access quickly.

Your bag should also contain a basic cleaning kit of lens tissues and a blower brush, spare batteries, a cable release and a lens hood for every lens if it's not built in. Digital shooters should also include a sensor-cleaning kit, power conversion adaptor plugs, a battery recharger and leads and a spare USB cable.

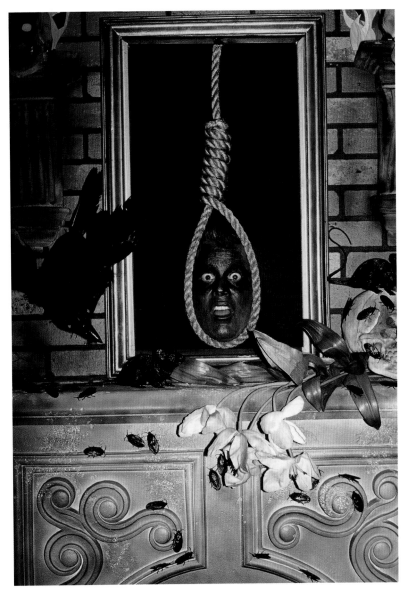

Halloween Party Parade float, West Hollywood, USA

It's not every day you come across a guy with a noose around his head, peering out from a picture frame hanging above a brick fireplace on wheels and moving quickly down Santa Monica Blvd in the middle of the night. When you do, you'll be glad you're carrying a flash unit, even if the light it produces isn't the most flattering. It's more important to be able to capture the moment.

▲ 35mm SLR, 50mm lens, 1/60 f5.6, Ektachrome E100VS, flash

FILM & DIGITAL MEDIA

Everyone has their favourite films and brand of memory card. The best way to ensure you can complete your trip with your preferred media is to take it with you from home.

FILM

The choice of film type – colour transparency (slide), and colour or black-and-white negative film for prints – is a personal one and depends very much on your photographic vision and how you want to work with, store, distribute and present your images. Experience and experimentation will teach you which film type and speed suits your photography. The simplest scenario is to settle on one film type and carry it in two different speeds.

All SLR film-camera users should select 100 ISO as their standard film speed; it's suitable for the majority of picture-taking situations and subjects and the resulting fine-grain slides or negatives ensure you'll have no trouble making very large prints or quality scans.

For low-light situations, colour-transparency users should carry either 200 or 400 ISO film, which can be exposed at its nominated speed or push-processed two or three stops. Those using colour and black-and-white negative film should carry 400 ISO film for low-light situations.

Carrying enough film from home is especially important for colour-transparency users travelling to cities in less developed countries. Even if you can find the exact film you want, when you want it, it may not be fresh or it may not have been handled properly, and it will often be very expensive. In the cities of developed countries you can usually buy your favourite or second-favourite films, but be aware that with the growing domination of digital cameras fewer places are stocking the range and quantity of films they used to.

DIGITAL MEDIA

The digital media you use is determined by your camera, so DSLR users really only have one choice to make – how much memory to take. The answer is just as simple. Take as much as you can afford. Assuming you'll be shooting in the RAW (a noncompressed form of digital image) file format to attain the highest-quality digital file, a minimum of three 2 GB memory cards is recommended, as is a portable-storage device for transferring the images from the cards as they fill up (or each evening, if you're really efficient).

Three or more 2 GB cards and a portable-storage device, rather than one 6 GB or 8 GB card, is recommended for image security reasons. If your camera is stolen and the one card is almost full, you not only lose your gear but your photos as well. If the one card you have is damaged, you're also faced with losing all your photos or at least suffering major inconvenience and worry until you can try data-recovery options. Even if you're confident you can buy memory cards on the road, you don't want to have to abandon a photo session because you don't have a spare card in your bag.

The best two options for transferring images from a memory card are portable computers or dedicated portable image-storage devices. Portable computers (laptop or notebook) give you the ultimate flexibility in dealing with image files on the road, and are worth considering when your travel is city focused, particularly if you base yourself in decent hotels. The large screen allows accurate assessment of the images before deciding whether or not to delete them. You can also make copies on CD or DVD, email, caption, edit, catalogue and enhance the photographs using your preferred software as you go. However, portable computers are large, fragile, expensive and an attractive target for thieves.

The more compact portable-storage devices are light, easy to use and powered by rechargeable batteries. They accept most memory cards either directly or via an adaptor. Capacity ranges from 5 GB to 60 GB, allowing thousands of high-resolution images to be stored, ready to be transferred to a computer at a later date. The higher-priced units have LCD screens, so images can be reviewed any time and, just as importantly, allow visual verification of successful transfer. They are also easy to hide in hotel rooms, store in hotel safety deposit boxes and conceal from would-be thieves when you're travelling.

Remember to take the audiovisual (AV) cables that come with most digital cameras and let you connect your camera to a television set. Most cameras are PAL and NTSC compatible so you can view your pictures anywhere you can access a television. This makes review and selection easier and more fun than scrutinising your work on the small LCD screens on your camera or portable-storage device.

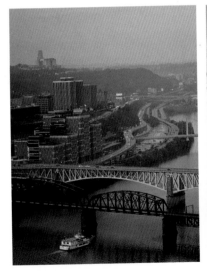

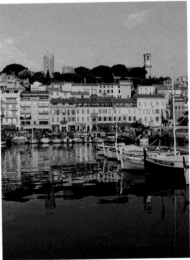

Bridges over Monongahela River from Mt Washington, Pittsburgh, USA

▲ 6 x 7cm SLR, 105mm lens, 1/60 f8, Ektachrome E100VS, tripod

Harbour at sunrise, Cannes, France

▲ Pro DSLR, 24-70mm lens at 40mm, 1/125 f10, 226 ISO, 4500 x 3000, RAW, tripod

Both pictures have captured the scene exactly as I saw it. The colours are true and saturated, contrast is good and the detail excellent; both images have reproduced well on the printed page and could easily be printed as large posters. One was recorded on film, the other on a digital sensor. Photography is about the image, not the equipment it was captured on.

TECHNICAL ELEMENTS

Exposure, composition and light are the key creative tools that allow you to turn your photographic vision into reality. They build on the creative choices you've already made in selecting a camera and lens, film or digital media. They give you the ability to see, select, organise and translate onto film or sensor the elements of a scene that appeal to you into a visually cohesive and unique image.

Wat Phra Kaew at dusk, Bangkok, Thailand
◄ 35mm SLR, 80-200mm lens at 200mm, 1 sec f11, Ektachrome E100VS, tripod

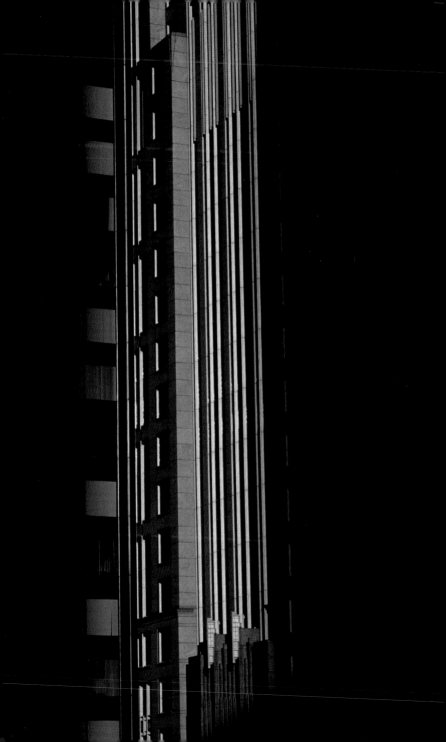

EXPOSURE

When you take a photograph, you're translating what the eye sees through the lens onto the film or image sensor. The choices you make when setting the exposure play a big part in determining how well the translation happens.

Correct exposure means the film or sensor is exposed to just the right amount of light to record the intensity of colour and details in the scene that attracted you to take the photo in the first place. It's achieved through a combination of the film or sensor's ISO rating and the selection of the aperture and shutter speed.

You can let the camera make these decisions for you by selecting a fully automatic exposure mode. However, that deprives you of the ability to control key aspects of the picture-taking process that determine how your pictures look, particularly in relation to the creative use of blur and depth of field.

For general hand-held photography the semiautomatic shutter-priority auto mode is recommended. You select the shutter speed and the camera automatically selects an appropriate aperture. In this mode you can't accidentally let the shutter speed drop too low and run the risk of camera shake, and it's easy to bracket in third- or half-stop increments.

DETERMINING EXPOSURE

Most modern cameras have built-in exposure meters that measure the amount of light reflected from the subject. All meters work on the principle that the subject is mid-tone, ie not too light or too dark. In practice, most subjects are a mix of tones, but when the meter averages out the reflected light, a mid-tone reading results in a properly exposed image. When very light or very dark subjects dominate scenes, exposure compensation is required.

When you point your camera at a scene, the meter recommends appropriate settings (depending on the exposure mode you've selected). You can accept the meter's recommendation or override it. One of the easiest and best methods of determining exposure is to expose for the main element of the image. In many cases this dominates the frame and exposure is straightforward. Difficulties arise when a scene contains large areas that are very light or dark, when shooting into the sun, when light sources are included in the frame, or when the subject is black or white. Try the following techniques when the lighting is difficult:

▶ Use the spot meter to take a reading off the subject.
▶ In manual mode, fill the frame with your subject, either by moving closer or zooming in, take a reading and then recompose, ignoring the meter read-out.
▶ In automatic mode, use the above technique but lock the exposure before you recompose or the meter will adjust the settings.
▶ On some fully automatic film SLRs, better compact digitals and all DSLRs, override the meter settings using the exposure-compensation dial that allows over- or underexposure of the film or sensor by third- or half-stops up to two or three stops. Turn the dial to +1 and you'll increase the amount of light reaching the film or sensor by one stop. Turn it to −1 and you'll decrease the amount of light by one stop. After adjusting the exposure-compensation dial, remember to reset it.
▶ Manually adjust the film's ISO rating to trick the meter into allowing more or less light onto the film. This can only be done on automatic film cameras if you can override the film-speed setting automatically selected by the DX (Data Exchange) coding. To overexpose 100 ISO film by one stop, change the ISO setting to 50, thereby doubling the amount of light that

Last light on skyscraper, Chicago, USA
◀ 35mm SLR, 180mm lens, 1/250 f8, Ektachrome E100VS

will reach the film. To underexpose by one stop, set the ISO to 200, and half the amount of light that will reach the film. This technique can't be used with digital cameras as the image sensor's sensitivity to light is varied electronically and will automatically compensate with a change in the shutter speed and aperture settings. After adjusting the ISO setting, remember to reset it.

▶ If the subject is black or white, the meter will average out the scene to a mid-tone. Your black or white subject will be rendered as a mid-grey if you don't compensate or override the meter's recommended settings. For white subjects take a reading off the subject and overexpose by one or two stops. For black subjects underexpose by one or two stops. For subjects that are both black and white, it's best to try bracketing your photos (see below).

▶ Bracket your exposure. A standard bracket requires three frames of the same scene. The first is at the recommended exposure, say 1/125 at f11, the second generally at half a stop over (1/125 at f8.5) and the third at half a stop under the recommended exposure (1/125 at f11.5).

SHUTTER SPEED & APERTURE

Film speed or image-sensor sensitivity, shutter speed and aperture are all closely inter-related. An understanding of the relationship between these variables, and the ability to quickly assess the best combination required for a particular result, is fundamental to creative photography. With 100 ISO film in your camera, or the image sensor set at 100 ISO, point your camera at a subject and your light meter may recommend an exposure of 1/125 at f4. But by decreasing the shutter speed one stop to 1/60 and stopping down the aperture by one stop to f5.6, you could still make a correct exposure (because the smaller aperture compensates for the longer time that the lens is open). Similarly, 1/30 at f8 or 1/15 at f11 would also be correct exposures. If you chose to use 400 ISO film or set the sensor to 400 ISO under exactly the same conditions, you could select 1/500 at f4, or 1/250 at f5.6, or 1/125 at f8, or 1/60 at f11. All of the above combinations will ensure the film or sensor is exposed to just the right amount of light. You have to decide which combination will give you the effect you want by giving priority to one element over the other.

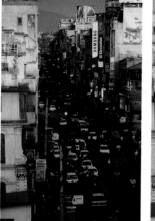

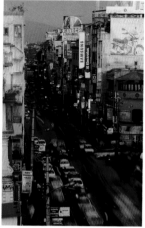

New Rd, Kathmandu, Nepal
The same scene can be portrayed quite differently through choice of shutter speed and aperture. The first image captures a realistic view of the street with the all movement frozen and excellent sharpness from front to back. The second image, taken with a much longer shutter speed, has recorded the moving vehicles as a blur, adding a dynamic element to the street scene.

▲ 35mm SLR, 24-70mm lens, 1/60 f4, Ektachrome E100VS, tripod

▲ 35mm SLR, 24-70mm lens, 3 secs f20, Ektachrome E100VS, tripod

DEPTH OF FIELD

Depth of field refers to the area of a photograph that is considered acceptably sharp. It is controlled by the aperture and is one of the most important creative controls available to the photographer.

The smaller the aperture, the greater the depth of field, and vice versa. An aperture of f16 will give maximum depth of field, while f2 will give minimum depth of field. For general photography use f8 or f11 as your standard aperture setting. These apertures will generally allow you to use a shutter speed of around 1/125, give enough depth of field for most shots and even give you some latitude against inaccurate focusing.

When you look through the viewfinder of a modern SLR you're seeing the scene through the lens at its widest aperture, or 'wide open'. This allows you to focus and compose through a bright viewfinder. The lens doesn't 'stop down' to the selected aperture until the shutter is released. As a result, you'll see your composition with very little depth of field. If your camera has a depth-of-field or preview button, you can get an idea of what will be in focus at any chosen aperture by manually stopping down the lens before taking the shot. Select an element of the image that appears out of focus and watch it come into focus as you stop down from f4 to f5.6 to f8. With each stop the viewfinder will get darker, but as you practise this technique the usefulness of controlling depth of field will soon become apparent.

Two other variables affect depth of field: the focal length of the lens and the distance between the camera and the subject. At the same f-stop, shorter focal-length lenses (eg 24mm or 35mm), will give greater depth of field than telephoto lenses (eg 135mm or 200mm). The further away your subject, the greater the depth of field. Move in close and you'll reduce the depth of field. So, maximum depth of field can be achieved by focusing on a subject over 50m away and using a wide-angle lens at an aperture of f16. Depth of field will be minimised by focusing on a subject under 5m away and using a telephoto lens at an aperture of f2.

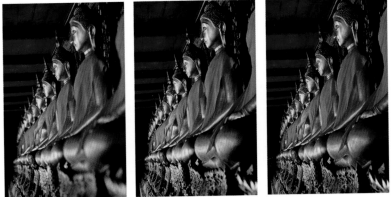

▲ 35mm SLR, 100mm lens, 1/60 f2, Ektachrome E100VS, tripod

▲ 35mm SLR, 100mm lens, 1/8 f8, Ektachrome E100VS, tripod

▲ 35mm SLR, 100mm lens, 1/2 f16, Ektachrome E100VS, tripod

Buddha statues at Wat Suthat, Bangkok, Thailand
A few stops this way or that with the aperture control and you can create quite different images without moving your camera. This row of Buddha statues can be photographed so that they are all perfectly in focus (right); all out of focus except one, in this case the statue second from the right (left); or somewhere in between (middle). Make it your business to always know what shutter speed and aperture combination you're using, even if the camera is set on full auto mode.

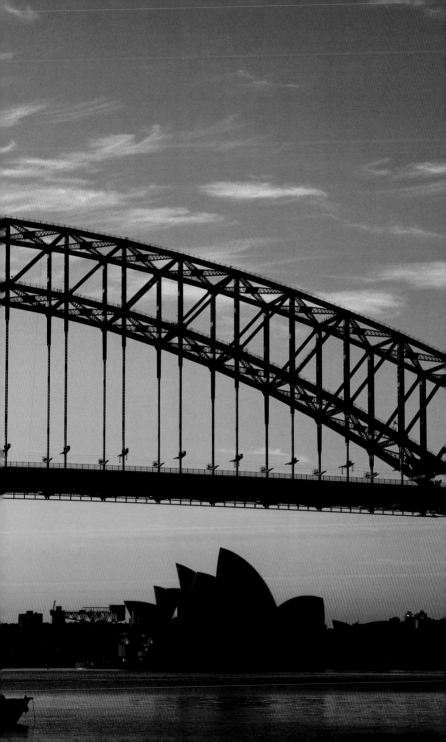

COMPOSITION

Composition is a creative act that allows you to encapsulate in a single. frame the subject matter that you think is worth photographing in a way that is pleasing to the eye. If you do it well, it will be pleasing to other people as well. The challenge of composition is to select and organise the various elements before you into a visually cohesive image. Experience and practice will teach you how to create striking compositions quickly. Along the way you'll develop your own preferences and style.

There is no one perfect composition for any given subject or scene and it's often worth trying several different compositions. Photographers regularly work the subject, exploring the different possibilities, all the time taking photos. However, all compositions are the direct result of the choice of lens, point of interest, camera viewpoint, content and orientation.

CHOICE OF LENS

The focal length of your lens determines the angle or field of view, subject size, perspective and depth-of-field potential.

Angle of View
The focal length determines the angle of view and refers to the image area that the lens provides. On a 35mm film camera or DSLR with a full-frame sensor, a standard 50mm lens covers an angle of 46 degrees, which gives about the same angle of view and subject size as the human eye. Wide-angle lenses provide a wider angle of view and smaller subject size than a standard lens. Telephoto lenses have a narrower angle of view and a larger image size than standard lenses.

Perspective
Perspective refers to the relative size and depth of subjects within a picture. When the angle of view is wide (with wide-angle lenses), the perspective becomes more apparent as it's stretched. Objects that are close by appear much larger than those in the background. With a narrower angle of view (with longer focal lengths), distances are compressed and become less apparent – distant objects look like they're directly behind closer ones.

Depth-of-Field Potential
The wider the angle of the lens, the greater its depth-of-field potential. The longer the focal length of the lens, the more its depth-of-field potential is reduced. (See p29 for more information on depth of field.)

Harbour Bridge & Opera House at sunrise,
Sydney, Australia
◀ 6 x7 SLR, 200mm lens, 1/4 f16, Ektachrome 50STX, tripod

POINT OF INTEREST

Successful images have a point of interest: the key element around which the composition is based and which draws and holds the viewer's attention. It's probably the thing that caught your eye in the first place. Aim to place this element away from the centre of the frame as this often contributes to a static composition. Also avoid including other elements that conflict with the main subject. Look at the space around and behind your subject and make sure nothing overpowers it in colour, shape or size.

As you're thinking about where to place the point of interest, keep in mind the 'rule of thirds' that has traditionally been the starting point for successful composition. According to this rule, the frame is divided into three sections, first horizontally and then vertically. You position your centre of interest roughly where the lines intersect.

Always focus on the point of interest. If something else is the sharpest part of the composition, the viewer's eye will rest in the wrong place.

Old town from Parc du Château, Nice, France

Having a clear point of interest is particularly important in busy photos, but much harder to achieve. By following the rule of thirds (as shown in the smaller image) and positioning the pink church tower away from the centre, the eye is forced to scan the image and is then led naturally to the tower by the sweeping black curve of the street, which is completely in shadow.

◀ 35mm SLR, 80-200mm lens, 1/60 f11, Ektachrome E100VS, tripod

VIEWPOINT

The position of the camera is important for two reasons. Firstly, in conjunction with your choice of lens, it determines what elements you can include and how they are placed in relation to each other. Secondly, it determines how the subject is lit by its position in relation to the main light source.

Don't assume that your eye level or the first place you see your subject from is the best viewpoint. A few steps left or right, going down on one knee or standing on a step, can make a lot of difference. Varying your viewpoint will also add variety to your overall collection.

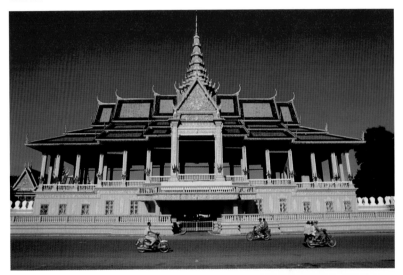

Royal Palace, Phnom Penh, Cambodia

These two pictures of Cambodia's Royal Palace clearly illustrate how easy it is to create two very different images of the same place, simply by altering the position of the camera. From front on the open-sided architecture is prominent, but from the side, less than 100 metres away, there is no suggestion of this architectural feature.

▲ 35mm SLR, 24mm lens, 1/250 f11, Ektachrome E100VS

▶ 35mm SLR, 100mm lens, 1/250 f8, Ektachrome E100VS

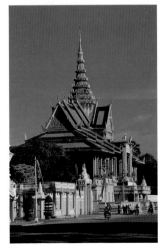

CONTENT SELECTION

Good compositions leave no doubt as to the subject of the photograph. A good way to start is to fill the frame with your subject. This helps to eliminate unnecessary or unwanted elements and overcomes the common mistake of making the subject too small and insignificant, which leaves the viewer wondering what the photo is supposed to be of. Often just taking a few steps towards your subject or zooming in slightly will make an enormous difference.

What you leave out of the frame is just as important as what you leave in. Do you really want power lines running across the façade of the most beautiful building in the city? It's fine if you do, but not if you didn't notice them in the first place. Scan the frame before pressing the shutter release, looking for distractions and unnecessary elements. If you have a depth-of-field button (p29), use it to bring the foreground and background into focus, which will help you spot unwanted elements.

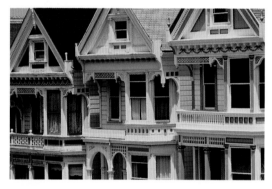

Victorian terrace houses, San Francisco, USA

Deciding what to leave in or out of the frame is another simple but powerful creative tool. If you didn't know San Francisco and the top photo is all you had, you'd have no idea of the relationship between the terrace houses and the city. This isn't a problem if you've deliberately chosen not to reveal the connection, as the image works well on its own merit. However, a very different impression of the terrace houses is created when their location is revealed in a wider composition that includes the skyline.

▲ 35mm SLR, 180mm lens, 1/250 f8, Ektachrome E100VS

▼ 35mm SLR, 100mm lens, 1/125 f11, Ektachrome E100VS

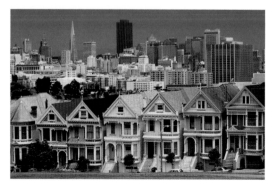

ORIENTATION

Consider whether the subject would look best photographed horizontally or vertically. Camera orientation is an easy and effective compositional tool and often a quick way of filling the frame and minimising wasted space around the subject.

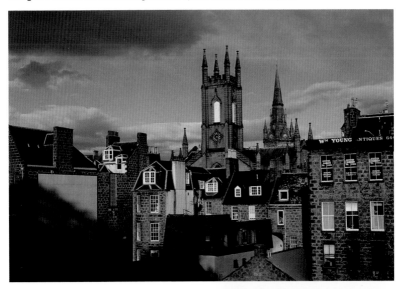

Churches & city buildings, Aberdeen, UK

Both images work well as stand-alone compositions but portray the churches in quite different ways. The horizontal composition shows them in relation to surrounding buildings but also includes a distracting blank billboard on the left of the frame. The vertical version is more clearly a photograph of the church towers themselves; it eliminates much of the context and relegates the houses they rise above to incidental status.

▲ 35mm SLR, 100mm lens, 1/125 f5.6, Ektachrome E100VS

▶ 35mm SLR, 180mm lens, 1/250 f4, Ektachrome E100VS

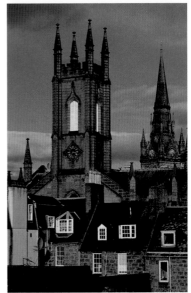

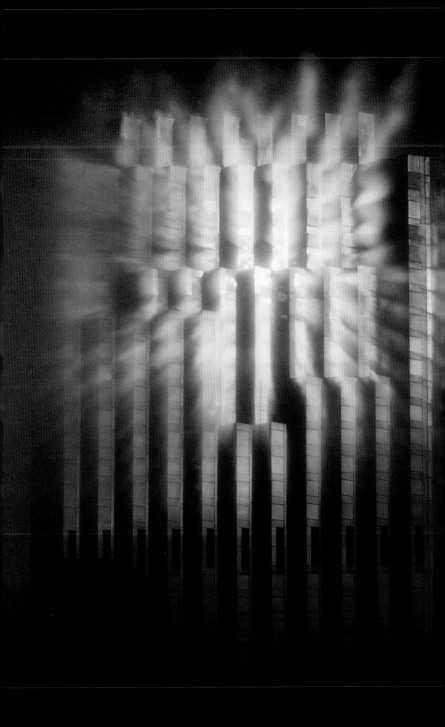

LIGHT

The ability of light to transform a subject or scene from the ordinary to the extraordinary is one of the most powerful tools at the photographer's disposal. To be able to 'see' light and to understand how it translates onto film or sensor and how it impacts on your compositions is the final building block in creating striking images.

In the urban environment you need to be confident working with the natural light of the sun for most of your daytime photography, incandescent lighting indoors or at night and flashlight when the available light is too low.

NATURAL LIGHT

The colour, quality and direction of natural light change throughout the day. As your eye settles on a potential subject, note where the light is falling and select a viewpoint that makes the most of the natural light to enhance your subject.

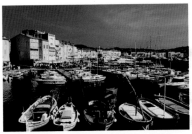

▲ 35mm SLR, 24-70mm lens, 1/250 f8, Ektachrome E100VS

▼ 35mm SLR, 24-70mm lens, 1/8 f11, Ektachrome E100VS, tripod

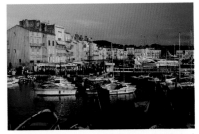

▲ 35mm SLR, 24-70mm lens, 1/60 f11, Ektachrome E100VS, tripod

▼ 35mm SLR, 24-70mm lens, 1 sec f11, Ektachrome E100VS, tripod

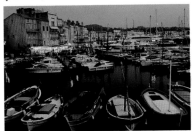

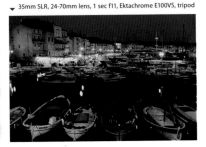

Harbour, St-Tropez, France
Just before three in the afternoon, on a warm summer day, head out to the sea wall overlooking the harbour at St-Tropez and stand there for around 6½ hours and you'll get a crash course in how the colour, quality and direction of the light impacts on the photos you take. Alternatively, you can study the four pictures above, taken at 3pm, 6pm, 9pm and 9.30pm respectively. The colour variations captured in these images are repeated every day (weather permitting) on outdoor subjects all over the world. The task for the photographer is to photograph every subject in the best possible light.

Sunburst through fog on the Bank of America Center, San Francisco, USA
◀ 35mm SLR, 180mm lens, 1/250 f5.6, Ektachrome E100VS

There is an optimal time of day to photograph everything, so be prepared to wait or return at another time if you can't find a viewpoint that works. However, most subjects are enhanced by the warm light created by the low angle of the sun in the one to two hours after sunrise and before sunset. At these times shadows are long and textures and shapes accentuated. If you're serious about creating good pictures, this is the time to be shooting the key subjects on your shot list.

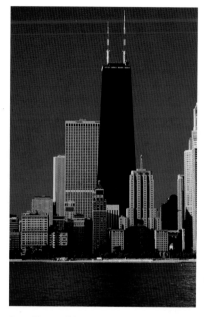

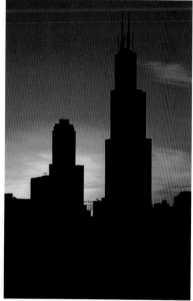

Sears Tower, Chicago, USA

On a clear, sunny day, a couple of hours after sunrise the Sears Tower is lit by front lighting, coming from directly behind the camera's viewpoint. Front lighting produces clear, well-saturated and pretty standard pictures.

▲ 35mm SLR, 180mm lens, 1/250 f8, Ektachrome E100VS

Sears Tower at sunset, Chicago, USA

When the sun is directly in front of your camera your subject will be backlit. Silhouettes at sunrise or sunset are the result of back lighting, which works particularly well if the subject is distinctive enough to be recognised by its shape.

▲ 35mm SLR, 100mm lens, 1/30 f11, Ektachrome E100VS, tripod

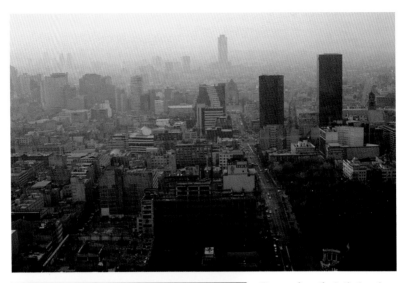

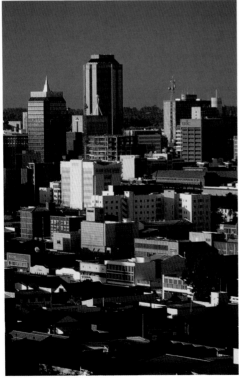

City seen from the Latin American Tower, Mexico City, Mexico

Shooting into the sun reduces colour saturation and detail so it doesn't suit all subjects, and you have to be careful not to introduce lens flare onto your film or sensor. However, don't disregard it altogether, as it can be effective if used for the right subject and carefully managed. The pollution haze over Mexico City is more clearly visible in this backlit view than it was when looking away from the sun.

▲ 35mm SLR, 100mm lens, 1/125 f4, Ektachrome E100VS

City skyline from the Kopje, Harare, Zimbabwe

Side lighting late in the day produces good colour saturation and contrast, bringing out textures and emphasising shapes. These qualities have been used to good effect to produce a strong image of the city that doesn't have a spectacular point of interest on its skyline.

◀ 35mm SLR, 180mm lens, 1/250 f5.6, Ektachrome E100VS, polarising filter

INCANDESCENT LIGHT

When taking photographs after dark or indoors we often have to rely on incandescent, or artificial, light sources such as electric light bulbs, floodlights or candles.

When you find yourself in dimly lit interiors, don't assume you need flash. As a rule, if you can see it you can photograph it. By using a tripod or other camera support you'll be able to shoot in low-light situations with your standard fine-grain film or preferred sensor setting. Alternatively, increase the sensitivity of you camera's sensor or change to a fast film to hand-hold the camera in very low light.

There are good reasons for being prepared to work with the available light. Most importantly, you'll be able to take pictures in many places where the use of flash is impractical (floodlit buildings, displays behind glass); prohibited (churches, museums, concerts); intrusive (religious ceremonies); or would simply draw unwanted attention to your presence (shops and shopping centres).

If you use daylight film in incandescent light, your photos will have a yellow orange cast. The strength of the cast varies depending on the light source. The cast can be neutralised by using tungsten film balanced for incandescent light or light-balancing 82 series filters (see p19). More often than not, the warm colours are appealing and help capture the mood of the location.

Digital camera users don't have to worry. All digital cameras have an auto white-balance function that adjusts the colours to ensure that white is recorded as white under all lighting conditions. Most cameras also have a range of presets that typically include tungsten and fluorescent-lighting settings. If you're shooting RAW (a noncompressed form of digital image) files, you can also fine-tune the white balance in your image-conversion software before processing.

Buildings on Largo do Senado, Macau, China
Taken late at night to eliminate the influence of natural light, this photo shows how various types of incandescent light used in and around the buildings on this square record as different colours on daylight film.

▲ 35mm SLR, 24mm lens, 1 sec f16, Ektachrome 50STX, tripod

FLASHLIGHT

Flash provides a convenient light source that will let you take a photo even in the darkest places without having to change films or sensor setting or use a tripod, as long as the subject is within the power range of your unit. You'll find yourself in lots of these low-light situations, particularly after dark, at cultural and live-music shows, restaurants, bars and nightclubs.

Most modern compact cameras and SLRs have built-in flash units. Otherwise a separate flash unit can be mounted on the camera via the hot-shoe or off the camera on a flash bracket with a flash lead. However, pictures taken with flash from built-in or hot-shoe mounted units are usually unexceptional. The direct, frontal light is harsh and rarely flattering. It creates hard shadows on surfaces behind the subject and backgrounds are often too dark. Much more pleasing pictures result by using bounce and fill-flash techniques and by combining flash with the ambient light (see p149).

Patrons at the Juke Box Bar, Bucharest, Romania
Flashlight doesn't have to be a bright, nasty atmosphere killer. By bouncing the flash off the low white ceiling, a reasonable area of the bar has been illuminated and the warm mood and light has been retained.

◀ 35mm SLR, 24-70mm lens, 1/30 f8, Ektachrome E100VS, flash

MIXED LIGHT

At the beginning and end of each day, the urban environment provides the opportunity to mix daylight with incandescent light as streetlights come on; light switches are flicked on in homes, offices and shops; monuments and statues are brought to life with floodlights; and the headlights and rear lights of city traffic are turned on. In the half-hour or so before sunrise and after sunset, cities and buildings take on a completely different look and feel and the images you capture will add an extra dimension to your collection. The best time to photograph is around 10 to 20 minutes before sunrise or after sunset, when incandescent lighting is the dominant light source, but there's still some light and colour in the sky.

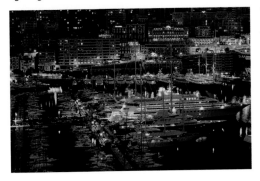

Harbour at dusk, Monaco Ville, Monaco
Without doubt the mix of natural and incandescent lights produces the most attractive urban images. The greater the number and variety of light sources the more magical the effect.

◀ 35mm SLR, 24-70mm lens, 6 secs f11, Ektachrome E100VS, tripod

BEING PREPARED

There are plenty of things you can do, both at home and at your destination, to ensure you not only make the most of your photo opportunities but create them as well. Simply shooting as you go along will rarely provide enough opportunities to be in the right place at the right time. Research, planning and practice will result in more and better pictures.

Woman with green painted face, Melbourne, Australia
◀ 35mm SLR, 100mm lens, 1/125 f8, Ektachrome E100VS

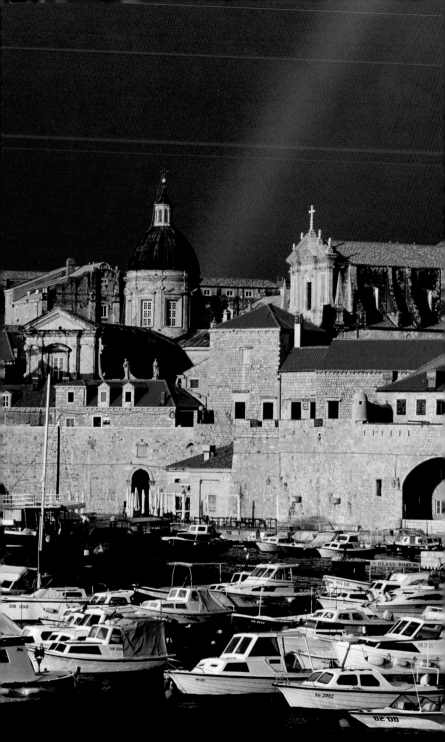

BEFORE YOU TRAVEL

You can learn a lot about a place that will help you make photo-friendly decisions in the planning stage and begin your familiarisation process well before you arrive in a new city. Guidebooks, magazines, pictorial books and Internet sites contain all the background and inspiration you need to get an initial sense of a place. Armed with this information you'll be in a much better position to determine when to go, where to stay, what to see and how long you may need there.

The less time you have to travel, the more thorough your research and planning should be. If time is of the essence, you really don't want to miss the best sights. Nor do yout want to spend valuable time walking to a place to discover that it would have been better to visit at another time of day.

WHEN TO GO

Assuming you're free to go any time, don't book your flights until you've checked out two key factors: the dates of special events and festivals, and the weather.

Festivals are a highlight on the calendar of cities large and small. They provide so many great photo opportunities that you should try to plan your trip around the dates of the festivals at your destination. Also, check the dates of the public holidays, as there are often special events associated with them.

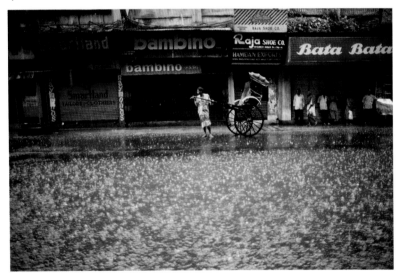

Rickshaw wallah in rain, Kolkata, India

The weather can really test your patience. Usually it rains when you don't want it to, but in this case I'd gone to Kolkata in August specifically to capture daily life during the monsoon, when streets can flood within minutes. After four days of sunshine, it finally rained…on the morning I was leaving. I had to cram five days' worth of photography into one.

▲ 35mm SLR, 24mm lens, 1/60 f4, Ektachrome E200 rated at 400 ISO (1 stop push)

Rainbow over old city, Dubrovnik, Croatia

◀ 35mm SLR, 24-70mm lens, 1/60 f11,
Ektachrome E100VS, polarising filter, tripod

No matter how well you plan you can't control the weather, but you can increase your chances of getting the conditions you want by understanding the climate of the region you intend to visit. Again, knowing what and why you're taking photographs helps. If you want to photograph north Indian cities in the most pleasant conditions, time your visit for October and November. However, if your plan was to take pictures of streets flooded by monsoon rains, you'll be too late.

Day after day of blue skies isn't necessarily the aim; it might be great for sightseeing but is not so good for creative photography, unless you're specifically shooting for holiday brochures. Inclement weather can provide the atmosphere and light to create that surprising element that will make your images different. Ideally, you'll be in a place long enough to experience a variety of conditions, which will add interest to your image collection.

SHOT LISTS

As you make discoveries about the city create a shot list – a list of the subjects and places that you want to photograph. Group the subjects by location and make notes such as opening times and the best time of day to visit.

Circle each place on your guidebook maps. This will show you how much walking you can expect to do and will also give you an idea as to the best time of day to shoot each subject, simply by determining the position of the subject in relation to the rising and setting sun.

Gradually you'll build up a picture of everything you want to see and when to see it. In turn this will inform your decision as to the best area to stay and how many days you need to cover everything. Or it will get you prioritising to ensure you don't miss out on the main subjects in the number of days you have.

A well-researched shot list will make you the most informed person in town, but don't be afraid to stray from it. There will be plenty of interesting things to photograph that you haven't read about or seen pictures of, particularly the everyday activities of the local people.

LENGTH OF STAY

It goes without saying that the more time you have the more opportunities you give yourself to photograph more subjects in the best light.

Photographers demand more time in a place than the average camera-toting tourist. Although it's possible to cover a lot of ground in a day and work quickly through a shot list, the light is at its absolute best only twice a day. It's not easy photographing more than one or two subjects in that hour or so at the beginning and end of each day.

As a really rough guide, assuming your intention is to photograph as many subjects as possible, four nights and three full days will allow you to cover most cities reasonably well, although you'll need to set a cracking pace. Importantly, you'll be able to plan at least six sessions of photography in the best light.

Three more days will allow you to go beyond the expected and delve deeper into the life of the city and its inhabitants. You'll be able to explore lesser-known places and encounter people who don't see a lot of tourists. You'll benefit from being able to shoot at a more comfortable pace, increase your chances of getting great light at dawn and dusk and decrease the impact of bad weather days. The extra time will also allow you to experience the city on working days and over a weekend, when the atmosphere, activity and photo opportunities can vary considerably.

Don't forget to take into account the time of year and season that you're visiting. European summer days are very long and winter days short, whereas on the equator the sun rises and sets at about the same time every day.

WHERE TO STAY

Budget is often a primary factor in deciding where to stay, but to make your time most productive and enjoyable make sure you have an understanding of the size and layout of the city and the locations of the main sights before booking a room. Ideally, stay in as central a location as you can. Accommodation may be cheaper on the edge of town but you'll spend more money on taxis or have to walk further just to get to the action. You'll also have to get up earlier, return home later and carry around those extra bits of gear (such as your tripod) when you don't need them. It's a huge advantage to be able to pop back to your room to pick up and drop off gear as required, change and rest without losing valuable time travelling back and forth to your hotel.

Don't forget: always ask for a room on a high floor with a view, as you may be able to capture a great shot without even leaving your room.

Façade of bank building, Ljubljana, Slovenia
My hotel was directly opposite this very colourful building, but my room was on the wrong side of the corridor. Fortunately, the cleaning staff were more than happy for me to join them while they were servicing the right room on the right floor.

◀ 35mm SLR, 24-70mm lens, 1/60 f8, Ektachrome E100VS

PERFECTING YOUR TECHNIQUE

There's no better way to prepare for shooting in the urban environment than getting out there and doing it. You can photograph most of the subjects discussed in On the Road (p57) in any town or city in the world, including your own.

Planning and executing a shoot of your own city is a great way to practise your research skills, test your camera equipment, perfect your technique, develop your eye and get a feel for urban light. Buy a guidebook, check out the postcards and souvenir books and draw up a shot list. Treat the exercise exactly as you would if you were away from home. You'll quickly get an insight into just how much walking you can expect to do, how many locations and subjects you can expect to photograph in a day and how manageable your equipment is. You can then use this knowledge to plan your trips to the metropolises of the world a little more accurately to meet your own goals.

As a bonus, you'll be rewarded with a fresh insight into your own city. You're sure to see it in a different light, literally, and to discover subjects and places you didn't know about.

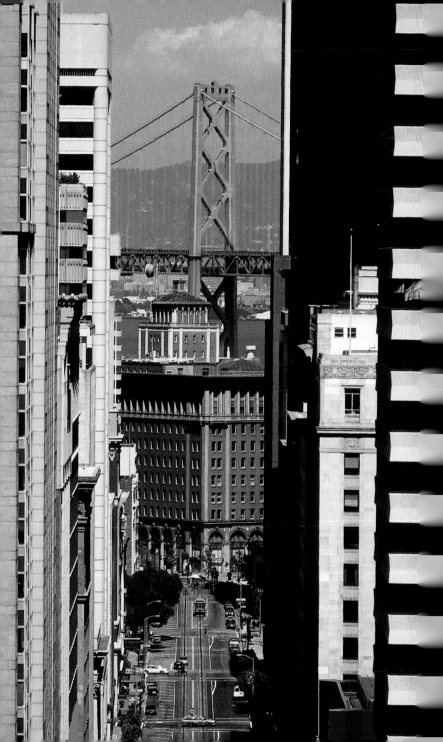

AT YOUR DESTINATION

You've done the research, refined your technique, taken a flight and made your way to your hotel. Now the fun really begins.

It doesn't matter how much reading and looking at pictures you've done – it isn't until you get out into the city yourself that you'll get any real sense of its scale, geography, layout and how and where the light falls at the time of year you're there.

Old town from Parc du Château, Nice, France
Research showed that the view from Parc du Château would be best in the morning, but what it didn't reveal was that the park had gates, and they're locked until 8am, two hours after sunrise. The quicker you check out key vantage points for yourself the better.

▲ Pro DSLR, 24-70mm lens at 70mm, 1/250 f11, 226 ISO, 4500 x 3000, RAW

EXPANDING YOUR RESEARCH

Although you'll be eager to spend most of your time exploring and taking pictures, take some time at the start of your visit to confirm key information from your pre-trip research and start to expand that research with local knowledge.

▸ Confirm the dates and times of festivals and events and establish the best places to be on the day.

▸ Confirm opening hours of places of interest.

▸ Confirm sunrise and sunset times (then you'll know what time you have to get up!)

▸ Check out what tours are on offer and assess their usefulness against your plans.

▸ Always assume there is more on than you know about. There are far too many local festivals and events for guidebooks to list. Don't assume that people will spontaneously inform you of what's happening.

▸ Seek information about interesting locations and what's on from a variety of sources, including the staff at your hotel and the local tourist office.

View to Bay Bridge, San Francisco, USA
◀ 35mm SLR, 100mm lens, 1/125 f11, Ektachrome E100SW

▸ Check that there are no access issues at the vantage points for your sunrise shoots, then work out how you're going to get there and how long it will take.

▸ Check out postcards, tourist publications, local magazines and books – they provide a good overview of the places of interest, as well as a guide to potential vantage points. This is worth doing regularly during your stay, as the images will make much more sense as your familiarity with the city increases.

FAMILIARISATION

For the photographer the aim is to get to know the city as quickly as possible. There's no better way to speed up the familiarity process than to get out and walk. Head for the city's main attraction – a city square, the beachfront or the harbour – and on this first sojourn ensure you get to at least one vantage point that overlooks the city. You'll quickly add first-hand knowledge to your research and the city map will soon make a lot more sense.

Also consider joining an organised city tour. They are offered everywhere and are useful to get a quick overview of a new city and its main sights; particularly in very large cities where walking everywhere isn't practical or even sensible. However, they have limited use for good photography as they're usually run in the middle of the day and give very little time at each destination. If your budget allows, forget the bus and do the same thing in a taxi. You can start earlier, finish later and spend as little or as much time at each place as you wish. If you get the right taxi driver, you'll find yourself with a personal guide who will be full of useful information that you can put to good use in the days ahead.

VANTAGE POINTS

As already suggested, make your way to a high vantage point that overlooks the city as soon as you can. Not only will it help you get your bearings and make the scale of the city clear, but you're pretty well guaranteed excellent photo opportunities.

Big cities often have official vantage points on nearby hills or at the top of tall buildings that provide great views of the city and beyond. Local postcards and tourist brochures will feature these views and often reveal the time of day they were taken. If not, use your map to determine if it's best to head up in the morning, afternoon or either.

After taking in the city's well-known views, try to seek out different vantage points at various locations around the city so you can create unique photos. Smaller places may not advertise a lookout, but most taxi drivers will know where you can look out over their town. Hotels of all standards sometimes have rooftop bars, restaurants and swimming pools that can be easily accessed. Other views can be had from café balconies, shops windows and high-rise car parks. It's worth checking out a few of these possibilities during the day, noting where the sun will set and rise, and returning later to the best-placed viewpoints.

North Lake Shore Dr from John Hancock Centre, Chicago, USA

With 360-degree views, skyscraper observation decks are usually worth visiting twice to see the entire city in the best light.

◀ 35mm SLR, 100mm lens, 1/125 f8, Ektachrome E100VS

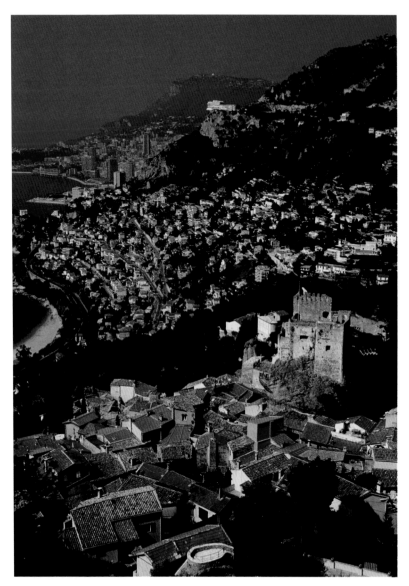

Castle & village, Roquebrune, France

I knew there had to be a vantage point somewhere with a view of the village down to the coast and Monaco in the distance. With a taxi waiting and less than an hour to spare I headed straight for the cemetery, the highest point in the village. The view from every terrace was blocked by high walls and I'd admitted defeat when a caretaker who had seen me running around indicated for me to follow. Despite our lack of a common language, he showed me a trail behind the cemetery that led to a small clearing with the very view I envisioned.

▲ 35mm SLR, 24-70mm lens, 1/125 f11, Ektachrome E100VS, polarising filter

FINE-TUNING PLANS

As you're exploring the city, consider what you're learning and start fine-tuning your shot list. You may have to miss out on photographing a building because it's covered in scaffolding, a fountain may be dry, you may spend half a day photographing a festival that your pre-trip research didn't reveal or the weather may be playing havoc with your schedule.

Plan what you intend to do each day, paying particular attention to what you're going to photograph in the late afternoons, at dusk, at sunrise and in the early mornings. This will help you prioritise your schedule as reality takes over from research. This is an ongoing exercise that will keep you busy every time you sit down for a coffee or a meal.

TAKING NOTES

Take notes of what you've photographed, the time of day and where you took it from. Not only is this information important for captioning your pictures later, but it's an effective way to learn from your own endeavours and very useful if you wish to return at a later date.

It can be just as important to make notes when you haven't taken a photo. When you find a location or subjects that will make a great image but you either don't have the time, the light isn't right or the elements you want to include aren't in place, note the place and its appeal. Use your compass to establish a north point; this will indicate where the sun will rise or set and allow you to determine the best time of day to return and balance this with other factors, such as whether you want people in the shot.

Don't attempt to commit this knowledge to memory. It's easy to mix up the details of subjects, locations and time of day when you're taking a lot of photos in an unfamiliar place. It's also very easy to simply forget about potential shots, especially on a first visit, as you'll be overloaded with possibilities.

RESTRICTIONS

You will come across very few places in cities that have restrictions on taking photographs for personal use, particularly outdoors, but make sure you're aware of any cultural restrictions or local sensitivities to photography. Bridges in India and beaches in France both spring to mind as sensitive subjects, as do military installations and checkpoints everywhere.

Generally, you'll only need to seek permission when you want to take pictures (other than a couple of quick snaps) inside shops, cafés, restaurants, bars and nightclubs or other private businesses. These are difficult places to take decent pictures in quickly and without drawing attention to yourself, so it's wise and polite to seek permission before you pull out the camera.

Be aware, though, that seeking permission in some places can lead to a small-scale Spanish Inquisition, with numerous phone calls to off-site managers and the loss of a lot of time. Unless you're on assignment and have to get a shot in a particular establishment, it's easier to move on and ask elsewhere.

Setting up a tripod is the single quickest way to draw attention to yourself and can trigger security people into action. Large, modern shopping complexes and entertainment areas appear to be particularly sensitive. The logic seems to be that if you're using a tripod you must be a professional, so you should have permission.

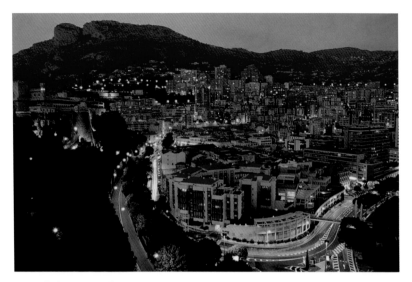

City at dusk, Monaco Ville, Monaco

This view is photographed every day by hundreds of people who visit the Palais du Prince (Royal Palace). But to capture it at the magical time when the lights of the city take effect requires a tripod and long exposures. I didn't know the security guy would ask me to put my tripod away (without a sensible reason I might add). Experience, however, has taught me not to set up until the very last minute in the most discreet manner possible, then to work really fast to get my shots, just in case. A method that obviously paid off here.

▲ 35mm SLR, 24-70mm lens, 4 secs f11, Ektachrome E100VS, tripod

SECURITY

You need to be alert and proactive to minimise the security risk to yourself, your equipment and your images. Cameras are, unfortunately, particularly attractive targets for thieves.

Most guidebooks will advise you to not walk alone at night on deserted city streets or through parks, but there may be other areas that are best avoided all the time. These no-go areas may be revealed in your pre-trip research, but get local and updated opinion from your hotel staff on arrival. It's better to deliberately investigate these areas than accidentally wander into them.

This is a particular issue in some urban areas at vantage points overlooking the city as they are often located in parkland and you'll either be there very early, when few people, if any, are about, or completing your photography after dark.

Things also change: the guidebook author may have had a bad experience on a particular day that coloured their advice, an area may have been completely revitalised as a result of commercial development, or security may have been increased to deal with the issue. However, if the area is considered risky and you still want to go there, hire a local guide or take a taxi and ask the driver to wait.

Being overly concerned about the security of your equipment doesn't only take the fun out of photography – it can prevent you from taking photos at all. A camera is no good at home, in the hotel, or at the bottom of the day-pack on your back. By taking sensible precautions and remaining alert, you should be able to access your camera quickly and easily and still retain possession of it.

Here are some tips to minimise the risk of having your photographic gear stolen:

▶ Carry the camera bag across your body, not on your shoulder – it's harder to snatch.
▶ Carry your camera around your neck, not on your shoulder – it's harder to snatch.
▶ Don't put your gear in an expensive-looking bag with 'Nikon' emblazoned on the side.
▶ If you have a top-opening bag, close it between shots.
▶ When you put your bag down, put your foot through the strap.
▶ Walk on the building side of footpaths rather than along the kerb so as to avoid motorbike thieves.
▶ Put your film, memory cards and portable-storage device in the hotel's safety deposit box.

View from the Carlton Centre, Johannesburg, South Africa

Johannesburg has a troubled reputation that's hard to ignore on your first visit, especially as it's reinforced by the locals. Consequently, I thought it prudent to hire a driver and guide to show me around and generally watch out for me. I didn't get mugged, so it must have been a good idea.

◀ 35mm SLR, 24mm lens, 1/125 f11, Ektachrome E100VS, polarising filter

ROUTINE & HABITS

Potential images come and go in front of your eyes in a matter of seconds and are easily missed. A good routine plays a big part in helping you react quickly to photo opportunities.

▶ Never leave your hotel room (or your house, if you're a home-bound traveller) without your camera. Even if you arrive in terrible weather conditions or there's only 10 minutes until sunset or you have a specific nonphotographic reason to be heading out, take your camera. Opportunities can occur at any time, even when you least expect it. It's almost guaranteed that these photo opportunities will be particularly interesting, unique and never to be repeated if you don't have your camera with you. Don't say you haven't been warned!

▶ If the weather is fine on the morning you arrive, it's very easy to assume that it will still be fine in the afternoon. This is a big mistake. If you're clear about your priorities, start at the top of the list if conditions are good. If you arrive in unfavourable conditions you can start with lesser priorities that are more suited to the conditions.

▶ Have your camera around your neck, switched on and with the lens cap off. You can't take pictures quickly if you have to get the camera out of a bag, remove the case, turn it on and take off the lens cap.

▶ Always wind the film on so that the shutter is cocked.

▶ Be aware of existing light conditions and have your camera set accordingly. Change the settings as conditions change. If using manual settings, adjust the aperture and keep the shutter speed appropriate for the lens you're using.

▶ If your camera is set on auto, make sure the shutter speed doesn't drop too low for hand-held photography without you realising.

▶ Have the lens you're most likely to need on the camera. For example, if you're on a crowded street looking for environmental portrait opportunities, a 24mm might be a good choice.

▶ Set zooms at the most likely focal length for the subject you're anticipating.

▶ Always change films as soon as a roll is finished, and memory cards when they're full, or even before. It's often worth changing film from frame 33, or memory cards when you only have a couple of shots left, if you think a photo opportunity could occur, rather than only having a couple of frames available when the action starts.

▶ Store full memory cards (in appropriately marked storage containers) separately from empty memory cards so you don't grab a full one when you're in a hurry (and have to spend precious time deleting images or finding another card before you can take photos).

▶ Always rewind the film completely into the canister so it can't be accidentally reused.

▶ Number each roll of film sequentially as you finish it.

▶ Prepare your gear each evening for the next morning's shoot so you're ready to go as soon as you wake up.

PART FOUR

ON THE ROAD

There's no shortage of subjects to photograph in the urban environment, even in the smallest of towns. This chapter illustrates and considers specific issues related to successfully photographing the most popular urban subjects. Use the subject headings as a shot list for your own photographic explorations and you'll be taking a big step towards capturing the character and diversity of the places you visit.

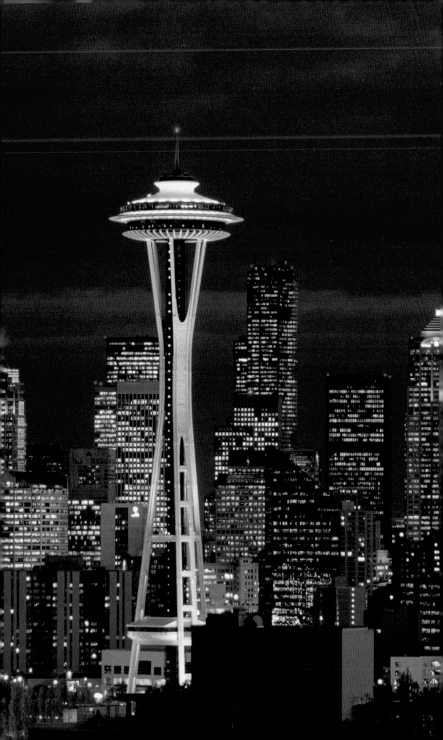

SKYLINES

Every large city has a unique skyline and getting to a vantage point in the first or last hour of the day should be a top priority in every city you visit. The classic skyline – a panoramic view of the skyscrapers and buildings in the city's central business district – is a great opening image for albums or slide shows and provides a context for the photos that follow.

Many cities have well-known vantage points on nearby hills or in public spaces along rivers or around harbours. Often there will be several viewpoints with different perspectives on the city. These will feature in local postcards, souvenir books and tourist brochures, giving you a good idea as to which location will offer the shot you're after. Vantage points are sometimes on city outskirts, so find out how to get there and how long it will take. If the viewpoint is on the remote side or in a park, it's more practical and often wiser to pay a taxi to wait for you.

Use a map to determine the direction of the sun in the morning and evening and thereby establish the best time to visit and capture the city in great light. No matter where the sun sets, you'll be rewarded with great pictures in the half-hour after sunset as the sky darkens and city lights begin to take effect. Even if the weather isn't good, make your way to the vantage point at this time. The combination of illuminated buildings, a darkening sky and long exposures creates dramatic and colourful images even on the worst of days. To capture these classic twilight skylines with maximum sharpness you'll need a tripod and cable release.

It's also worth taking your full complement of lenses to the viewpoint because they are never one-shot spots. You'll have the opportunity to capture all sorts of images, from entire city panoramas to the city's signature skyscraper, in various vertical and horizontal compositions. Just as importantly, until you've been there, you can't be sure just how far the lookout is from the city and you might end up requiring a 200mm lens to shoot the panoramic view.

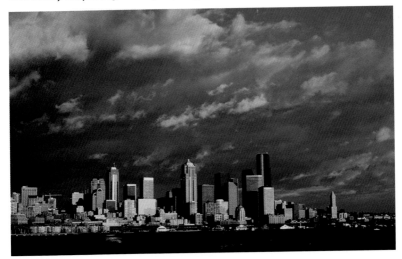

City skyline from Bainbridge Island ferry, Seattle, USA
Two very different views of the same city, from two very different locations. The Kerry Park view (left) is the classic skyline-at-dusk image, featuring the city's most prominent building. It's the must-have shot when planning a shoot in Seattle and is quite easy to organise. On the other hand, shooting a skyline from a moving ferry is a little trickier and requires a good range of focal lengths so you can capture the composition you want when a burst of late-afternoon sun lights up the city beneath a sky of dramatic storm clouds (above).
▲ 35mm SLR, 100mm lens, 1/250 f8, Ektachrome E100VS

Space Needle & city skyline from Kerry Park, Seattle, USA
◀ 35mm SLR, 180mm lens, 1 sec f11, Ektachrome E100VS, tripod

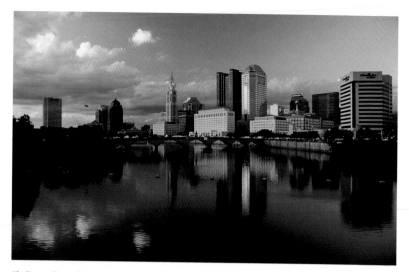

Skyline reflected in Scioto River at dusk, Columbus, USA

Cities built beside rivers are a real bonus for the photographer. Many and various vantage points along the riverbank and bridges are just about guaranteed. Not only do the reflections of the buildings in the river add a very photogenic element to the composition, but they also prevent linear distortion.

▲ 35mm SLR, 35mm lens, 1/2 f11, Ektachrome E100VS, tripod

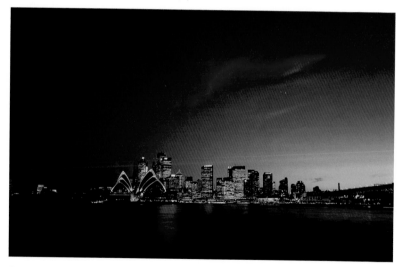

Opera House & skyline from Kirribilli, Sydney, Australia

The view from Kirribilli is one of several classic views of the Sydney skyline featuring the Opera House. Taken 20 minutes after sunset, the lights are bright, the sky dark and the sense of a city after dark strong. Exposure can be tricky as the contrast between the lights, sky and foreground increases. Take a reading from the lights then overexpose by up to two stops in half-stop increments to retain colour and detail in the sky and foreground.

▲ 6 x 7cm Rangefinder, 50mm lens, 4 secs f11, Ektachrome E100VS, tripod

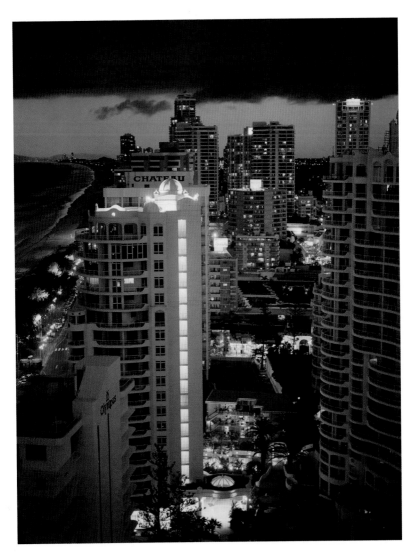

Surfers Paradise, Australia

At the end of a really bad weather day, with storm clouds still threatening, the high-rise strip at Surfers Paradise still looks great. At dusk always make your way to your chosen vantage point because even on the worst of days you can almost always guarantee pleasing results in the half-hour after sunset.

▲ 6 x 7cm SLR , 45mm lens, 6 secs f11, Ektachrome E100SW, tripod

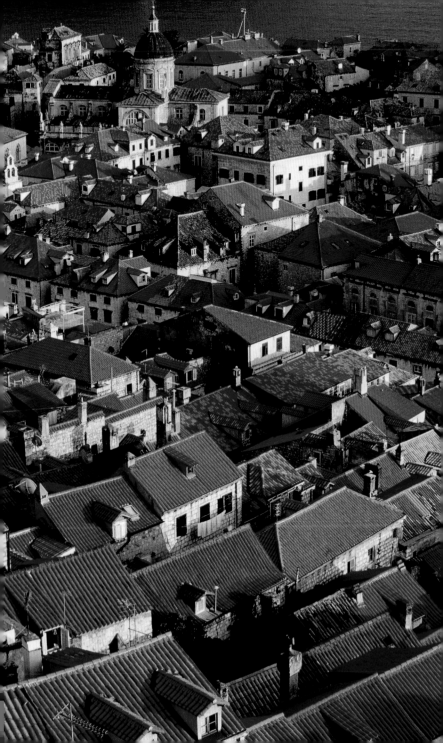

CITY VIEWS

Not all cities have impressive skylines, but an overview from a high vantage point provides great photo opportunities and the same scene-setting effect for a series of images. The vantage point for city views is usually in the city itself and easily accessible. Apart from official observation decks that are often in centrally located skyscrapers, keep an eye out for other vantage points that will give you the chance to create more unique images. Hotels sometimes have rooftop bars and restaurants that are easy to access, cafés with balconies are often situated around town squares, cathedrals sometimes have viewing platforms high in their spires and domes, and high-rise car parks are common in big cities. In hilly cities there are endless opportunities to find interesting views – it's just a matter of perseverance and stamina as to how many you discover. Check out a few during the day, noting where the sun will set and rise, and return later to the best-placed viewpoint.

City & Table Mountain from Signal Hill, Cape Town, South Africa
Signal Hill offers great views of Cape Town spreading out below the spectacular backdrop of Table Mountain. Taken right on sunset, the warm pink glow and soft, even light have combined to produce an attractive cityscape with plenty of detail in both the city buildings and the mountain.

▲ 35mm SLR, 50mm lens, 1/2 f11, Ektachrome E100VS, tripod

Old city, Dubrovnik, Croatia
Accessing the city view doesn't come any easier than in Dubrovnik. The old city is encompassed by ancient city walls that provide the perfect platform for shooting a classic city overview as well as a heap of other opportunities to find your own angles and subjects, from details of roof tiles to the perfect view down the city's most famous street.

◀ 35mm SLR, 80-200mm lens, 1/250 f8, Ektachrome E100VS

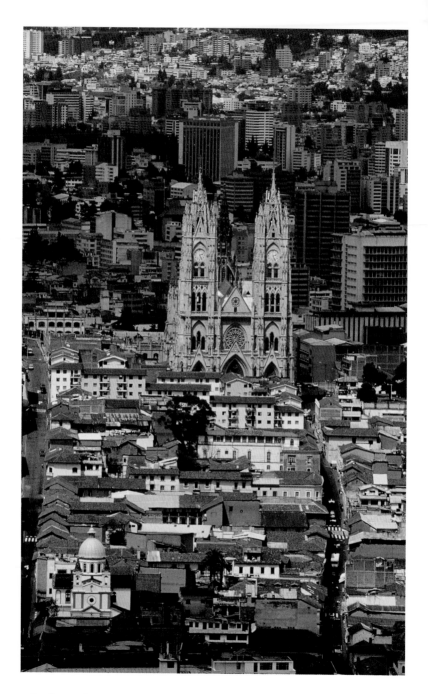

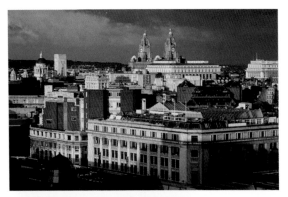

City at sunrise, Liverpool, England

Storm clouds and a burst of early-morning sun combine to bathe the city in a beautiful warm light. When there's a lot of cloud about, you have to anticipate the potential of the view and set up even in the dullest conditions. If the sun does break through, the light will be magical but often lasts only a couple of minutes, as it did in this case.

◀ 35mm SLR, 100mm lens, 1/30 f11, Ektachrome E100VS, tripod

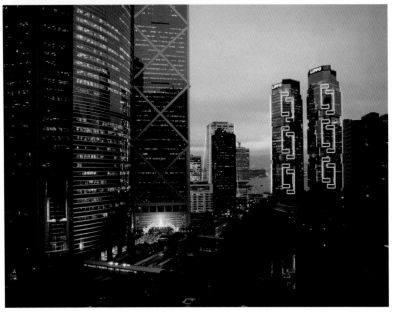

Skyscrapers in Central, Hong Kong, China

City views don't need to be panoramic to tell a story. The sheer bulk and enormous size of the skyscrapers is clearly suggested by including only the lower sections of the foreground buildings. That they seem to dwarf other obviously tall buildings is further emphasised by the perspective created by a wide-angle lens, which makes the closer buildings appear much larger than those in the background.

▲ 6 x 7cm SLR, 45mm lens, 1/2 f11, Ektachrome 100STZ, tripod

View from the tower of the Church of La Basilica, Quito, Ecuador

With stunning 360-degree views of Quito, the church tower is a 'must climb' for photographers. The transition between the old and new districts is clear, but this image emphasises it by capturing the shifting sunlight (due to cloud and wind) as it falls on the cathedral and old city, leaving the modern district in shade.

◀ 35mm SLR, 100mm lens, 1/125 f8, Ektachrome E100VS

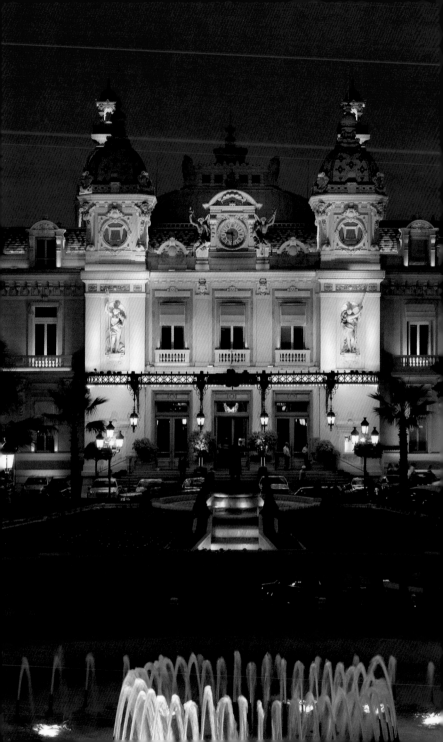

ARCHITECTURE

Cities are defined by their architecture. Their histories and aspirations are clearly manifest in the buildings that line the streets, overlook the squares and house institutions. Photographing architecture is an integral step in creating a collection of images that capture the soul of a city.

The most famous buildings are major drawcards and deservedly high on everyone's shot list. They should be given priority in terms of time and commitment to photographing them well, because it's easy to take boring pictures of buildings. Simply walking up to a building and grabbing a shot will rarely do the job. Don't forget you're photographing someone else's creativity, so try to do it justice.

One of the main difficulties faced is getting far enough away to capture an entire building without causing converging verticals in the image. Tilt your camera up to photograph a building and it will appear to be falling backwards. Look down on a building and it will appear to lean towards you. The wider the lens and the closer you are to a building, the more pronounced the effect. Converging verticals or linear distortion can be effective, however, when the composition exaggerates the distortion. Looking up at skyscrapers is a good example of this technique. To record buildings faithfully, the camera's film or sensor plane must be parallel to the vertical surface of the building. Unless you're carrying a perspective-correction (PC) lens (p18), this is most easily achieved by:

▸ Finding a viewpoint that is half the height of the building that you're intending to photograph.

▸ Finding an interesting foreground to fill the bottom half of the frame.

▸ Moving away from the building and using a telephoto lens.

Rock & Roll Hall of Fame at dusk, Cleveland, USA
Shooting at just the right moment, about 10 minutes after sunset, the light was perfectly balanced to show the exterior detail of this modern building as well as revealing the mood and colour of the interior.
▲ 35mm SLR, 24mm lens, 1 sec f8, Ektachrome E100VS, tripod

Casino at dusk, Monte Carlo, Monaco
◀ Pro DSLR, 24-70mm lens at 48mm, 1/6 f6.3, 226 ISO, 4500 x 3000, RAW, tripod

If you're really serious about keeping your horizontal and vertical lines straight, a spirit-level accessory is most useful. Some tripod heads have them built in, or you can buy an accessory that fits into the camera hot shoe. The best of these have two spirit levels, one for horizontal accuracy and another for vertical accuracy.

Once you've established a viewpoint and lens combination that doesn't bend the building (too much), you have two or three opportunities each day when the light is right. This is either early in the morning or late in the afternoon, depending on which way the building faces, and, when it's illuminated, in the half-hour before sunrise or after sunset. There's no point taking the picture at all if the main façade is in shade.

As with skylines, photographing illuminated buildings in the half-hour before sunrise or after sunset offers guaranteed results regardless of the weather and ensures you get the shot even if your schedule doesn't allow you to get back to photograph the building at the right time of day. If, in order to avoid converging verticals, you've chosen a viewpoint that offers an interesting foreground to fill the bottom half of the frame, be aware that the foreground must also be illuminated, otherwise you'll have an unacceptably large area of the composition in shadow.

Look for opportunities to include people in architectural pictures. They add scale, colour, movement and interest. If you don't want to include people or other elements such as parked cars or traffic, and don't want to put your patience to a severe test, photographing early in the morning is usually the best opportunity you'll have.

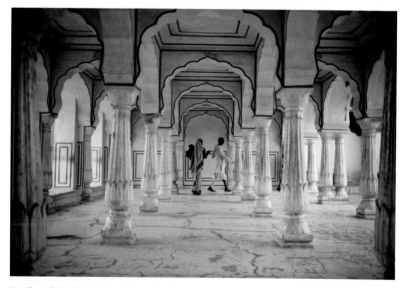

Family walking through pavilion at Amber Fort, Jaipur, India
This open-sided pavilion at Amber Fort lends itself perfectly to including a human element in an architecturally interesting composition. Seeing the potential for a picture was the easy bit – waiting for the right people to walk through the right arches was a real test of patience.
▲ 35mm SLR, 24mm lens, 1/125 f5.6, Kodachrome 64

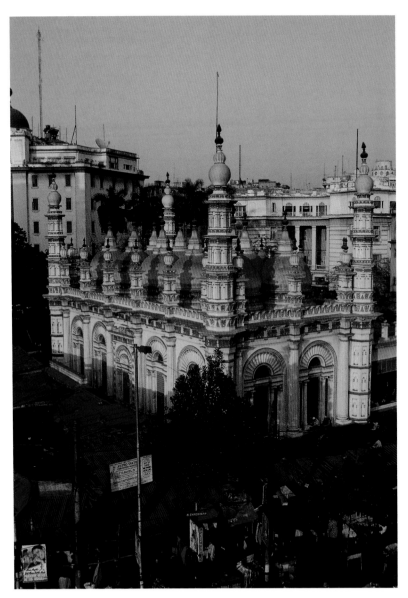

Tipu Sultan's Mosque at sunset, Kolkata, India

The warm colour and low angle of the sun just before sunset bring out the texture and detail of this small and very beautiful mosque. The shot looks straightforward enough; the skill here lay in being determined enough to find a vantage point, as the mosque can't be seen from the street. It's completely hidden from view by shops, stalls and advertising posters. The roof of a corner restaurant provided the solution.

▲ 35mm SLR, 24mm lens, 1/30 f8, Ektachrome E100SW, tripod

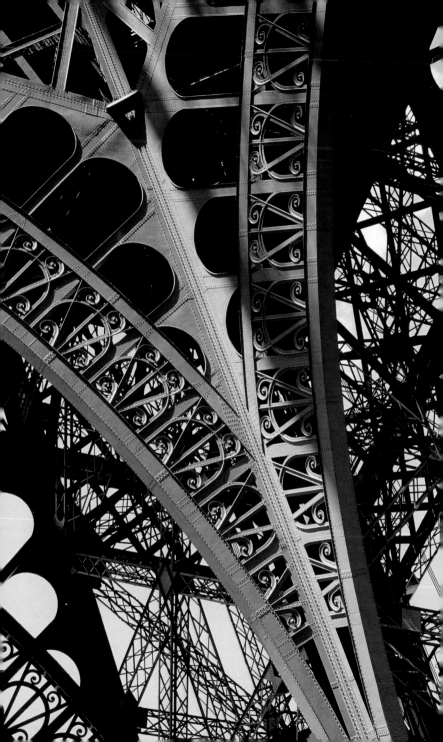

ARCHITECTURAL DETAILS

It's impossible to appreciate the fine architectural and artistic details that adorn many buildings in a photograph of the entire structure. Look to complement your architectural shot with close-ups of the most symbolic and graphic of these details. You can often do this from the same position by zooming in or changing lenses for the most obvious and grander details. Then walk in and around the building to ensure you see the more intricate work. Look for texture, shape, colour and pattern in the design and stroud of the building.

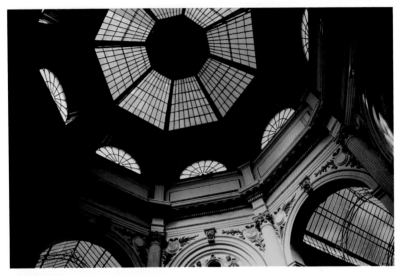

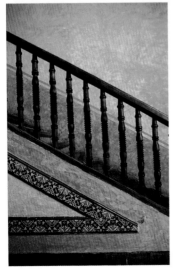

Interior of dome above arcade, Bucharest, Romania

This grand glass dome looms over an unassuming passageway that reveals nothing of its grandeur when you first peer in from the main street. Once inside though, the unusual colour of the light created by the coloured glass draws your eye upwards.

▲ 35mm SLR, 24-70mm lens at 24mm, 1/20 f8, Ektachrome E100VS

Guesthouse staircase, San Cristóbal de Las Casas, Mexico

Architecture doesn't have to be grand to inspire photography. By selecting a small part of the staircase and highlighting its repetitive diagonal lines, a graphic image has been made of a functional architectural element.

◀ 35mm SLR, 50mm lens, 1/125 f8, Ektachrome E100VS

Eiffel Tower detail, Paris, France

◀ 35mm SLR, 24mm lens, 1/125 f8, Ektachrome E100SW

Painting in hotel foyer, Xiāngchéng, China

Like many Chinese-built hotels, the exterior left a lot to be desired, but inside the Tibetan influence was clear, with a huge, colourful mural featuring fire-breathing dragons dominating the reception wall. The light levels dimmed quickly away from the entrance, so rather than try to depict the whole wall, impressive as it was, I filled the frame with an evenly lit detail.

▲ 35mm SLR, 24-70mm lens at 24mm, 1/60 f4, Ektachrome E100VS

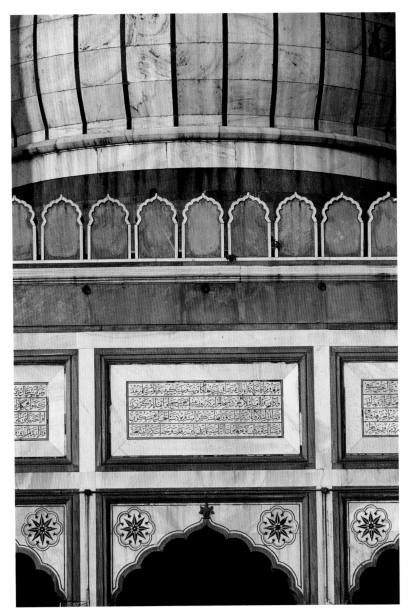

Jama Masjid, Old Delhi, India

With a simple change of lens, I was able to move from capturing this mosque's entire façade (see p18) to creating a graphic detail emphasising key elements of the mosque's Mughal architecture.

▲ 35mm SLR, 180mm lens, 1/250 f8, Ektachrome E100SW

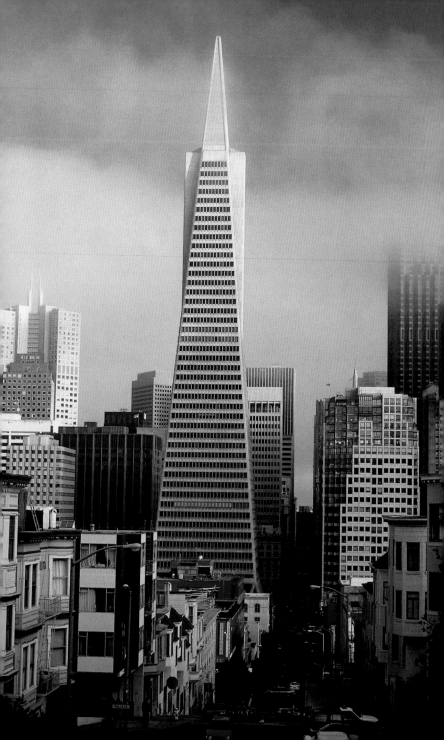

SKYSCRAPERS

Skyscrapers dominate the skyline and central business district of most large cities. They are often difficult to photograph as it's hard to get far enough away to get a clear view of an entire building from within the city. Even if your wide-angle lens is wide enough to capture most of the building from street level, you'll be looking up and your image will exhibit a serious case of linear distortion. That's fine if it's the effect you want, and skyscrapers are one type of building where it can work quite well, as it gives the impression of the building rising into the distance, which is exactly what it's doing.

Take the opportunity when you're photographing the skyline to pick out groups of or individual skyscrapers, as it may be the best view you get. Check out the same building from street level for a totally different view.

Skyscrapers are also often covered in glass, which provides reflections of the buildings around them or throws light onto other buildings. This often gives surprising results, as city streets and building façades that should be in shadow glow in the reflected light.

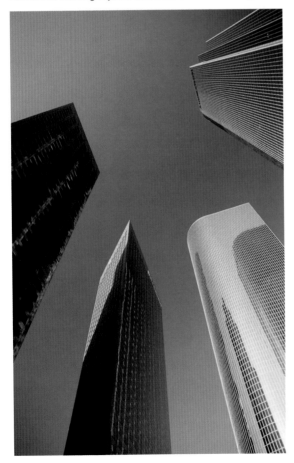

Skyscrapers on Bunker Hill, Los Angeles, USA

A classic case of linear distortion is created by looking up at skyscrapers with a wide-angle lens.

◀ 35mm SLR, 24mm lens, 1/125 f11, Ektachrome E100SW, polarising filter

Transamerica Pyramid, San Francisco, USA
◀ 35mm SLR, 50mm lens, 1/125 f8, Ektachrome E100SW

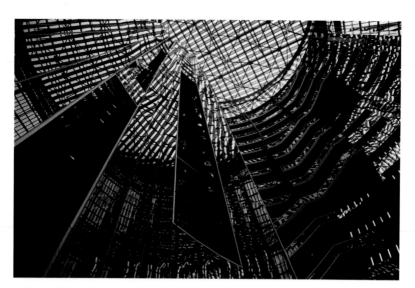

Atrium in the James R Thompson tower, Chicago, USA

Don't forget to check out the foyers of key buildings. Skyscrapers often feature dramatic atriums that rise many stories. The colour and texture inside the building will change throughout the day depending on the weather and position of the sun, so stop in a couple of times. In this image, conditions conspired to produce an unusual, almost monochrome effect to help create an abstract take on the subject.

▲ 35mm SLR, 24mm lens, 1/30 f5.6, Ektachrome E100VS

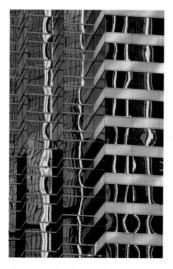

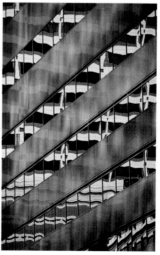

Skyscraper façade, Baltimore, USA

The reflective materials used on the exterior surface of many skyscrapers make great subject matter in their own right. The constantly changing reflections provide lots of opportunities for creating abstract images.

◀ 35mm SLR, 180mm lens, 1/250 f8, Ektachrome E100VS

Skyscraper façade, Hong Kong, China

▲ 35mm SLR, 80-200mm lens, 1/320 f13, Ektachrome E100VS

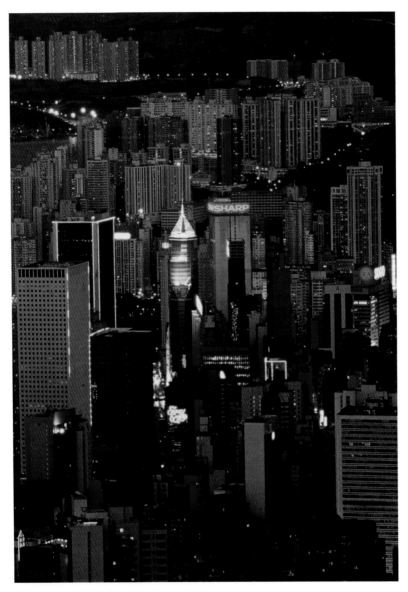

Skyscrapers in Central at dusk, Hong Kong, China

Hong Kong Island is paradise for the skyscraper aficionado. Not only are there hundreds of very tall buildings crammed onto a tiny piece of real estate, but there is an easily accessible and outstanding vantage point at Victoria Peak from which to enjoy them.

▲ 6 x 7cm SLR, 105mm lens, 8 secs f11, Ektachrome 100STZ, tripod

LANDMARKS

Every city has buildings and monuments on its must-see list. London's Tower Bridge, Paris' Eiffel Tower, the Sydney Opera House and the Capitol Building in Washington DC… These are places whose image is already deeply etched in our mind's eye well before we stand before them ourselves. If you want a real challenge, set yourself the triple task of taking pictures of a city's landmark buildings that are as good as the published images, then look to create a different photograph from those you've seen before and finally get close and fill the frame with a portion of the building to create an abstract but recognisable view.

The Classic View

Spend five minutes looking at postcards or pictorial books of the city you're in and you'll soon get a feel for what are considered the classic views of the city's landmarks.

The classic view is absolutely worth taking, but the challenge is to do it as well as or better than it's already been done. In many places it's easy to get to the vantage points and replicate well-known pictures. That's no problem – it's a famous view because it's a great view of a great building, but it's better to treat it is a starting point for your own interpretation. Do this through your choice of viewpoint, lens and, of course, the light you shoot in. When you're shooting well-known sights, the light has to be fantastic or your shot just won't compare.

Glass Pyramid & Louvre at sunset, Paris, France
Postcard-perfect views can be tracked down pretty easily by looking at local postcards. However, it's rarely as easy as it looks. The great light on the Louvre lasted about two minutes after a two-hour wait in cold, windy weather.

◀ 35mm SLR, 24mm lens, 1/30 f11, Ektachrome E100SW, tripod

Opera House & Harbour Bridge at sunrise, Sydney, Australia
It can take several early-morning starts to get perfect light and nice clouds over Sydney's bridge and Opera House.

◀ 6 x 7cm Rangefinder, 50mm lens, 1/2 secs f11, Ektachrome E100VS, tripod

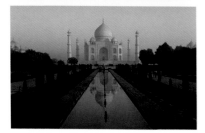

Taj Mahal at sunrise, Agra, India
There isn't always water in the reflection pool at the Taj and it wasn't until my third visit that it was free of scaffolding.

◀ 35mm SLR, 35mm lens, 1/60 f8, Kodachrome 64

Fireworks over the Washington Monument, Washington DC, USA
◀ 6 x 7cm SLR, 90mm lens, 6 secs f11, Ektachrome E100VS, tripod

A Different View

Once you've got your own take on the classic view, think about how you can photograph the building in a different way. This is often easier said than done, particularly with really famous buildings, as photographers have been trying to do this for years. This includes the locals, who obviously have more opportunity to do so and the advantage of local knowledge. It's still possible, but it takes a bit more effort than following the path to the classic view.

These shots require a combination of time, clever composition and great light. Apart from those rare moments when everything comes together on your very first visit, you'll need to invest some time to achieve a different view. Walk around the building, get up close and then view it at a distance. Compose as you go with a variety of focal lengths. Most importantly, make sure you're there when the sun is low in the sky and the colour of daylight is at its most intense, as the colour and quality of the light is the magic ingredient.

Another option is to leave the tourist trail in search of an unexpected angle, the opportunity to juxtapose the building against another or to show it in an unusual context. When you've found a suitable vantage point, go back there at the best time of day.

Louvre seen through glass pyramid at sunset, Paris, France

The idea of overlaying the modern architecture of the pyramid on the traditional architecture of the Louvre came together when the strong, late-afternoon light enhanced the colour and grandeur of the old while highlighting the intricate design of the new.

▲ 35mm SLR, 100mm lens, 1/15 f11, Ektachrome E100SW, tripod

Opera House & ferries, Sydney, Australia

Not many visitors see this view and Sydneysiders only glimpse it as they speed past in their cars. Taken from an elevated motorway, it presents the Opera House as a backdrop to a busy transport hub as ferries come and go from Circular Quay.

▲ 6 x 7cm SLR, 90mm lens, 1/125 f8, Ektachrome 100STZ, tripod

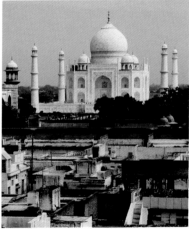

Taj Mahal & rooftops of Taj Ganj, Agra, India

The rooftops of the cheap hotels and restaurants of the Taj Ganj district, built to house the workers who built the Taj, offer great views showing the Taj in a totally different context from the reflection pool and manicured lawns of the compound in which it stands.

▲ 35mm SLR, 180mm lens, 1/250 f8, Ektachrome E100SW

The Detail View

Famous buildings don't have to be shown in their entirety to be recognised so, for a third shot in your series of images of each landmark, consider filling the frame with only a portion of the structure. Apart from creating an interesting photographic challenge, the images are often of more interest to viewers than the classic shot, which they are already familiar with.

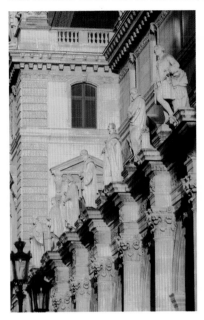

Louvre details at sunset, Paris, France

▲ 35mm SLR, 180mm lens, 1/30 f11, Ektachrome E100SW, tripod

Opera House roof detail, Sydney, Australia

▲ 6 x 7cm SLR, 200mm lens, 1/125 f11, Ektachrome E100SW, tripod

All three landmarks have fine architectural details that deserve to be highlighted. Fill the frame with key features such as the statues that top the columns of the Louvre, the distinctive roof tiles of the Opera House or the marble inlay of the Taj.

Marble inlay detail on exterior of Taj Mahal, Agra, India

◀ 35mm SLR, 180mm lens, 1/250 f8, Ektachrome E100SW

GALLERIES & MUSEUMS

Galleries and museums are often significant places in the city's psyche and their collections are housed in buildings as diverse as centuries-old, dark, musty mansions and purpose-built futuristic spaces. The exhibition areas vary enormously from place to place and even from room to room, presenting the photographer with various challenges.

Be clear what it is that you want to achieve. Unless you have set yourself the goal of cataloguing every item in the building, you don't need to photograph every room, exhibit or piece of art. Two or three images from each place will do; ideally, this will include an overview of the most impressive public space and a close-up of the most attractive exhibits. This will free you up to concentrate on finding exhibits that you can photograph well with the gear you have, rather than struggling to photograph a particular thing with the wrong gear.

Photographing the interiors of galleries and museums requires the ability to switch from one technique to another depending on the amount of available light and the restrictions placed on photo-taking by the establishment.

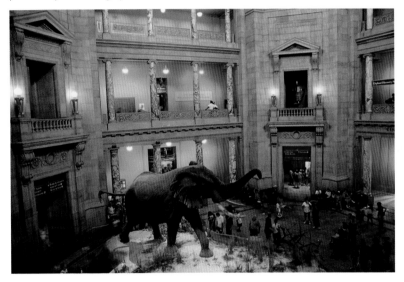

Rotunda, National Museum of Natural History, Washington DC, USA
The handrails on the balconies overlooking the display in the rotunda provided the ideal platform on which to rest the camera for a long exposure. Not being secured to a tripod, and because there was no urgency, I used the self-timer to ensure steadiness, rather than a cable release.
▲ 35mm SLR, 24mm lens, 1/2 f2, Ektachrome E100VS

In many galleries and museums flash and tripods are prohibited, so in dimly lit spaces there's no choice but to increase sensor sensitivity or use fast film. Even if flash is permitted, a single flash unit will rarely be powerful enough to light up a room and, when used within its range on individual exhibits, the results will be pretty ordinary, giving you a record shot at best. Also, many displays are behind glass, so you'll have to turn the flash off to avoid an image-ruining highlight as the flashlight bounces straight back into your lens. The main advantage of a tripod is that you can use your standard sensor setting or fine-grain film and still achieve good of depth of field.

Gemini Exhibit, National Air & Space Museum, Washington DC, USA
◀ 35mm SLR, 24mm lens, 1/30 f8, Ektachrome E100VS

However, before you change your sensor settings or film, spend the first half-hour or so (depending on the size of the place) looking around and establishing which exhibits or rooms you want to capture and how best to do it. If you start shooting as you go along, especially in a large, many-roomed building, you could spend your time in difficult-to-photograph rooms when there is a much easier situation next door or on the next floor. Using ambient light will better capture the atmosphere of the exhibition spaces, so look for rooms that have a mix of daylight and incandescent light; are flooded with daylight (from windows or skylights); or individual exhibits placed near windows or lit with spotlights intense enough to allow the camera to be hand-held.

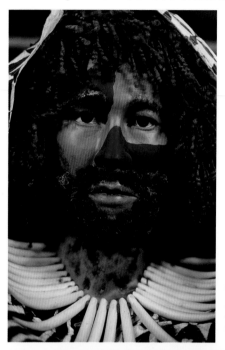

Warrior chief exhibit, Fiji Museum, Suva, Fiji

Protected from prying hands by a glass display case and in very low light, this exhibit could still be photographed without a tripod by placing the lens directly on the glass for support. This method also eliminates the possibility of image degradation from reflections.

◀ 35mm SLR, 50mm lens, 1/4 f1.4, Ektachrome E100VS

Historic figures exhibit, Sung Dynasty Village Wax Museum, Hong Kong, China

Sometimes you just have to use flash. When the displays are under very dim lights and you don't have or can't use a tripod, a straight flash picture will at least give you a bright, colourful photograph.

◀ 35mm SLR, 50mm lens, 1/4 f1.4, Ektachrome E100SW, flash

Bat display, Louisville Slugger Museum, Louisville, USA

Baseball bats and balls hang from the ceiling, capturing the spirit of the museum in one frame. When you need to hand-hold your camera in low light, switch to your widest-angle lens or zoom out to the widest focal length, as you can hand-hold a camera at a shutter speed equivalent to the focal length of the lens. So, the wider the focal length, the slower the shutter speed can be without the risk of camera shake.

▲ 35mm SLR, 24mm lens, 1/30 f2, Ektachrome E100VS

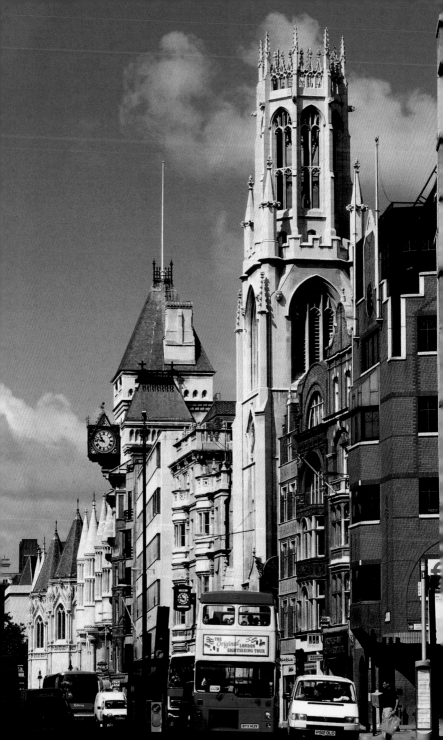

STREETSCAPES

Shanghai's Bund, New York's Fifth Ave, Memphis' Beale St, Dubrovnik's Placa and Paris' Champs Élysées are streets that demand to be photographed. Their very names conjure up images of the heart of the city. Every city has such streets (even if they aren't household names) – streets that are the city's commercial, cultural, tourist and transport focus for locals and visitors alike.

The most consistently effective streetscapes can be made with a medium telephoto or zoom lens setting around 100–150mm. These focal lengths allow you to pick a point of interest at least 100m away from your camera position and provide just the right amount of subject compression to give a realistic perspective between the foreground and distant elements in the street. This will create a dynamic and busy feel, and will keep the buildings parallel with the film or sensor plane so the verticals remain straight.

An elevated viewpoint works best, as it gives you the clear space you need in front of the lens to prevent foreground elements such as people and traffic from unbalancing the composition and blocking the view. Keep an eye out for 1st-floor windows and balconies, rooftops, bridges and pedestrian overpasses, as they all make ideal vantage points.

Street corner at Burra Bazaar, Kolkata, India
Don't just concentrate on famous streets. Scenes such as this in one of Kolkata's busy commercial districts offer a glimpse of life around the city and pack in plenty of information about architecture, transport, people and local government policy on the use of advertising signs! An elevated vantage point overlooking a corner is also a great opportunity to use a wide-angle lens to capture the view down two streets in one frame.
▲ 35mm SLR, 24mm lens, 1/125 f8, Kodachrome 64

Fleet St, London, England
◀ 35mm SLR, 100mm lens, 1/125 f8, Ektachrome E100SW

At street level find a viewpoint with some space in front of it. Even a slight rise in the road or standing on a couple of steps will let you shoot over the immediate foreground. Otherwise, standing on the kerb or in road intersections (once the traffic has cleared on your side of the road) will do. However, you need much more patience when shooting at street level.

When you're planning your shot and searching for a viewpoint, remember that when the light is at its best (early morning or late afternoon) one side of the street will usually be in shadow. Once the sun has set and the lights come on, you'll have your best opportunity to include both sides of the street in a single photograph.

Temple St, Hong Kong, China
Temple St is famous for its night markets, so to convey the night-time atmosphere I shot late at night, relying solely on street lighting rather than shooting in the mixed light after sunset as I typically do.

▲ 35mm SLR, 100mm lens, 1/30 f4, Ektachrome E100SW, tripod

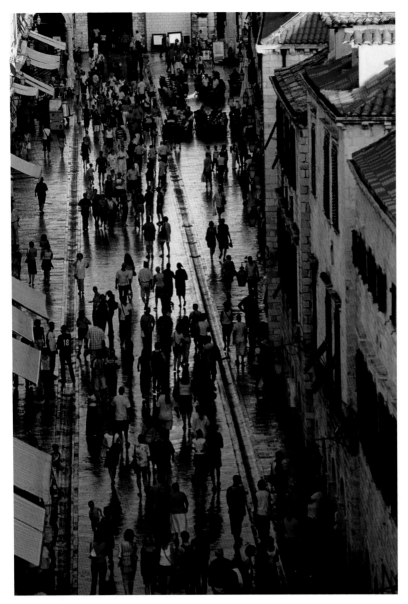

Pedestrians on Placa, Dubrovnik, Croatia

This is the most literal of streetscapes, with Dubrovnik's most famous street, Placa, as the point of interest. Shimmering as though wet, the marble flagstones are in fact lit up by the afternoon sun that's reflected from the light-coloured stone of the clock tower at the top end of the street.

▲ 35mm SLR, 80-200mm lens at 200mm, 1/250 f5.6, Ektachrome E100VS

STREET ART

Cities are full of street art, including high-profile sculpture installations in key locations, colourful murals on walls of all sizes, illicit graffiti scrawled across derelict buildings and statues of all shapes, sizes and significance.

You can photograph the art work in its entirety or focus on a detail to create an abstract image emphasising shape, colour or texture. Walk around, under and between large sculptures and installation art. Then check it out from a more distant position, observing how the light is falling and what the background options are. It can be portrayed in very different ways: as a static piece of art, a prominent or insignificant element in the streetscape or a backdrop to the hustle and bustle of city life.

Walls covered with murals or graffiti also make excellent backgrounds, so if the light is right take up a position, compose your image and wait for interesting people to pass by. In bright sunlight watch out for shadows and reflections that create uneven light. Our eyes and brain compensate for the difference in brightness, so they can be easy to miss, but images don't work if there is an unsightly shadow or a bright area blocking out detail in part of the composition. A polarising filter (p19) is often useful for this subject to cut down reflections and ensure saturated colours.

Statues often result in some of the most boring pictures imaginable, as people feel obliged to photograph them but rarely give much thought to the image. They are often made of very dark materials so the details are hard to see and they end up looking like silhouettes. That's fine if it's deliberate, but not so good if you intended to see the detail. Early morning or late afternoon side light will bring out the detail and texture and add a touch of colour, bringing even the dullest of statues to life.

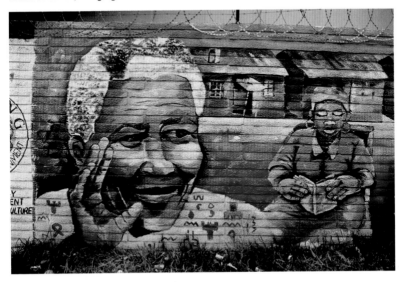

Nelson Mandela mural, Soweto, South Africa
Murals do make great photographic subjects, either in their entirety or by selecting the most graphic or colourful elements to create your own piece of art. From a travel-photography perspective, they're even better if the mural's subject matter reveals its location.
▲ 35mm SLR, 50mm lens, 1/125 f8, Ektachrome E100VS

Detail of decorated bus, Ljubljana, Slovenia
◀ 35mm SLR, 24-70mm lens at 70mm, 1/125 f8, Ektachrome E100VS

Sculpture on Bogovićeva, Zagreb, Croatia

For a less literal view of street art, look for opportunities to create an image using only part of the sculpture or artwork. Tight framing of the graffiti on this street sculpture and shooting in low light has created an image with an edgy, inner-city feel. This is not exactly the feeling you get when you're there, viewing it from one of the many smart shops or outdoor cafés that line the pedestrian street it's located on.

▲ 35mm SLR, 24-70mm lens at 24mm, 1/30 f5.6, Ektachrome E100VS

Statue of Oliver Cromwell, London, England

Late-afternoon sun reveals the shape and texture of a statue that is typically portrayed, like most pictures of statues, as a solid, black and featureless object.

▶ 35mm SLR, 100mm lens, 1/125 f5.6, Ektachrome E100SW

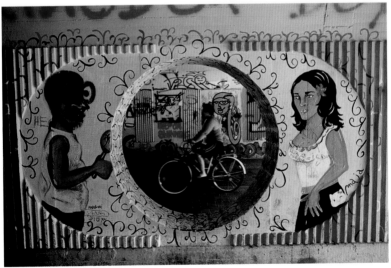

Mural & graffiti in underpass, Ljubljana, Slovenia

The murals and graffiti were interesting enough, but this underpass, with its circular hole in the dividing wall, also provided an ideal opportunity to include a human element as a steady stream of pedestrians and cyclists passed through.

▲ 35mm SLR, 24-70mm lens, 1/60 f8, Ektachrome E100VS

URBAN DETAILS

Change your focus from the grander subject matter of skylines and architecture and you'll discover a whole new world of less obvious but equally interesting subjects. The subjects are the kinds of things that most people take for granted and walk by without a second look, but for the sharp-eyed photographer they're important in creating an overall impression of the city. Frame-filling close-ups of walls, signs, decorated bus-shelters and lamp posts, shop-front decorations, café menu boards and posters add colour, texture and personality to your collection. Look out for urban details that are unique and recognisable as belonging to the city.

The other great thing about these subjects is that many of them can be photographed at most times of the day in any weather, so they're great for filling in the time when the circumstances aren't right for shooting other subjects. You can also continue your search for urban details well into the night with well-lit subjects such as neon signs and street lights. You'll need your tripod and cable release, as exposures are generally long. To record detail, overexpose by one and two stops. As with all difficult lighting situations, bracketing (p28) is recommended.

The ideal lens for capturing many urban details is a medium telephoto or zoom lens set to a focal length around 100–135mm. You'll be able to fill the frame with your subject without having to get too close or without getting down on your knees.

Personnel hole cover, New York, USA

Commissioned to take this shot for a book cover, I spent hours inspecting personnel hole covers on the streets of New York. Typically, the right one was in the middle of a road, so I organised someone to watch out for traffic – it's not a shot worth getting run over for. Finding an urban detail that includes the name of the city is an interesting alternative to the skyline or city view as a title image for presentations.

▲ 35mm SLR, 100mm lens, 1/125 f4, Ektachrome E100VS

Chewing-gum wall, Seattle, USA

All my research failed to reveal one of Seattle's hidden secrets. Fortunately, a friend working in the city knew I'd be impressed by this most unusual wall featuring hundreds of pieces of old chewing gum. It's a work in progress, so it can only get bigger and better.

◄ 35mm SLR, 50mm lens, 1/60 f2, Ektachrome E100VS

Decorative lights for Chinese New Year, Singapore

You can find urban detail possibilities almost anywhere. The Chinese lanterns in the foreground were decorating a set of traffic lights and street signs in the middle of a road. When light sources are in the frame, shoot some extra frames and overexpose between half a stop and two stops to retain detail in the less bright areas.

▲ 35mm SLR, 100mm lens, 1/2 f8, Ektachrome E100SW, tripod

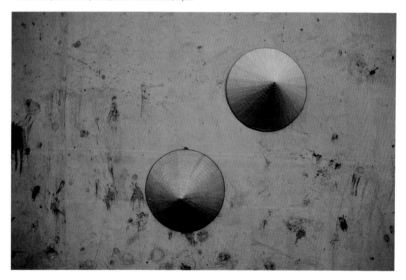

Conical hats on wall, Hanoi, Vietnam

Even a single element can tell you where the shot was taken if it's an iconic symbol of the country, as these conical hats of Vietnam are.

▲ 35mm SLR, 24mm lens, 1/125 f4, Kodachrome 64

Glass monument on the Malecón 2000, Guayaquil, Ecuador

This fascinating, modern-glass monument could keep you entertained for hours. It's the perfect subject to experiment with depth of field, as very different images can be made by varying the point of focus and aperture. Turn off the autofocus function, as multiple options prevent the lens from determining the point of interest.

▲ 35mm SLR, 35mm lens, 1/60 f2, Ektachrome E100VS

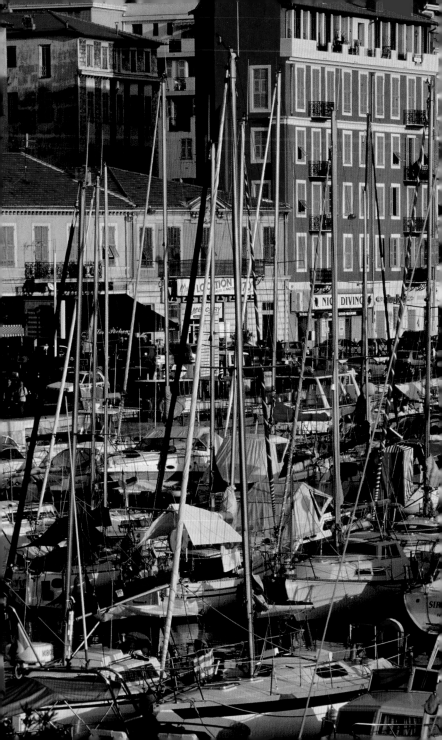

WATERFRONTS

Waterfronts often present one of the liveliest and most colourful areas in the urban environment. Riverbanks lined with shops, restaurants and parks are a focal point for recreational activities, while in other places they are a hub of daily life, as people wash and dry clothes and themselves. Harbours and marinas packed with boats of all shapes, sizes and colours and lined with interesting buildings, mix commerce and pleasure as transport, fishing and shipping activities occur side by side.

Start wide and high if you can for a scene-setting shot of the area, then move in to focus on the boats and architecture. Move in again to see the activity around the piers, esplanades and water's edge, and then get really close for detail pictures of fishing nets, boat hulls and reflections in the water.

Apart from the beautiful light, if you shoot early or late in the day you'll be there when there is heightened activity on and around the boats and the reflections are at their best.

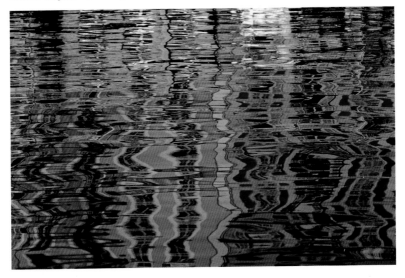

Reflections in Bassin Lympia, Nice, France
Surrounded on three sides by colourfully painted buildings that produce brilliant reflections in the water, and packed with pleasure boats of all sizes and a fleet of small fishing boats, Nice's Bassin Lympia (Lympia Harbour) is extremely photogenic. The real bonus though is that it receives great light early in the morning and late in the afternoon.

▲ 35mm SLR, 80-200mm lens at 200mm, 1/250 f5.6, Ektachrome E100VS

Yachts in Bassin Lympia, Nice, France
◀ 35mm SLR, 80-200mm lens at 200mm, 1/250 f11, Ektachrome E100VS

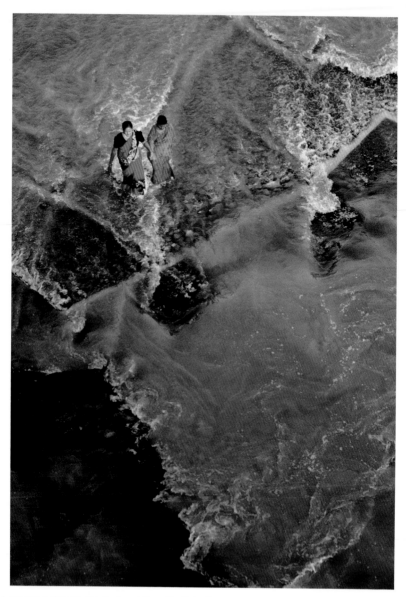

Women walking in the Godavari River, Nasik, India

Where there are rivers there are bridges. These provide great vantage points and sometimes surprising views, such as these two women heading towards the churning waters under the bridge. They soon turned back but gave me a unique image, as I managed to leave out the thousands of people crowding into the river to bathe just behind them.

▲ 35mm SLR, 24-70mm lens at 70mm, 1/125 f8, Ektachrome E100VS

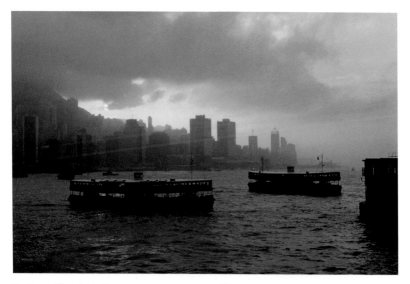

Ferries on Victoria Harbour at sunset, Hong Kong, China

At the end of a bad weather day, I made my way to the waterfront, aiming to shoot the Hong Kong Island skyline as the city lights came on. I photographed the ferries in the dull, fading light while I waited, hoping the sun would break through and light up the scene, just like this. It pays to be an optimist in this job.

▲ 6 x 7cm SLR, 105mm lens, 1/60 sec f5.6, Ektachrome 100STZ, tripod

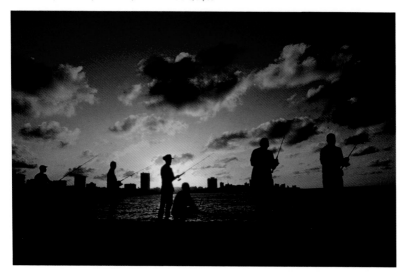

Fishing at sunset on El Malecón, Havana, Cuba

People fishing make good subjects to silhouette against a dramatic sky. By placing a figure in front of the setting sun, the light meter wasn't tricked into underexposing the scene and turning the sky black.

▲ 35mm SLR, 24mm lens, 1/60 f8, Ektachrome E100VS

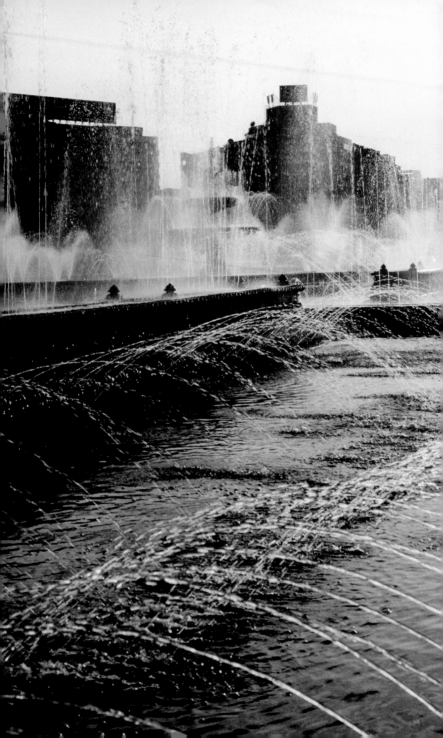

FOUNTAINS

Fountains are often the centrepiece of city squares or traffic islands. They add a softening visual element to the urban landscape, and the sound of running water acts as a pleasing counter to traffic noise. They can look good at any time of the day but are particularly attractive in the early evening when illuminated, often with coloured lights. Use a tripod and slow shutter speeds of between four seconds and 1/15 of a second to blur the water and create a very pleasing velvety effect.

Consider the fountain from all angles. Photograph it from a distance to show it in context and then look for compositions that focus on part of the fountain for a less literal image. When the sun is low, take advantage of back and side lighting to capture different colours and moods in the water. If there is a breeze, look out for rainbows forming in the water's spray. The height, shape and intensity of the water often varies, so give yourself 10 minutes to make sure you're photographing the fountain at its best. By the way, don't assume the water will flow all day every day – in many places it is turned on and off.

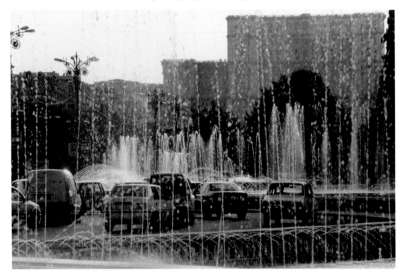

Traffic & fountain in Piaţa Unirii, Bucharest, Romania

This is a serious fountain, or rather a serious series of fountains, that fill the large Piaţa Unirii and make for a very picturesque roundabout for the drivers of Bucharest. By shooting into the sun just before sunset, the backlit water is transformed and captured as a golden, translucent and obviously fleeting element. Because there was so much water, I used a shutter speed that would capture the detail and texture of the jets and sprays rather than a slow shutter speed that would blur them into each other.

▲ 35mm SLR, 24-70mm lens at 70mm, 1/125 f5.6, Ektachrome E100VS

Fountain in Piaţa Unirii, Bucharest, Romania

◄ 35mm SLR, 24-70mm lens at 24mm, 1/125 f5.6, Ektachrome E100VS

Fountain in Largo do Senado, Macau, China

This square is a popular place for a stroll in the evening, so I needed a composition that would minimise the time spent waiting for people to move out of frame. Additionally, because it was late in the evening I was relying solely on incandescent light and wanted to avoid dark areas such as the night sky. A short telephoto lens to decrease the angle of view (p29) and a background of illuminated buildings solved both problems.

▶ 35mm SLR, 100mm lens, 1 sec f8, Ektachrome 50STX, tripod

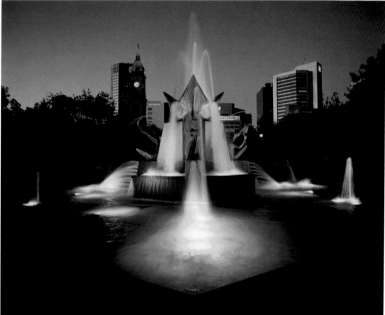

Victoria Sq Fountain, Adelaide, Australia

By shooting after sunset with mixed light, long shutter speeds can be used to blur the water to emphasise the softening effect fountains have on the urban landscape.

▲ 6 x 7cm SLR, 45mm lens, 4 secs f11, Ektachrome E100VS, tripod

Child playing in fountain at Tennessee Bicentennial Mall, Nashville, USA
On a scorching summer day the children were having a ball cooling off under the mall's fountains. It takes time to observe and prepare shots like this, so I sought out the child's parents and gained permission to spend a few minutes with my lens trained on her.

▲ 35mm SLR, 180mm lens, 1/250 f8, Ektachrome E100VS

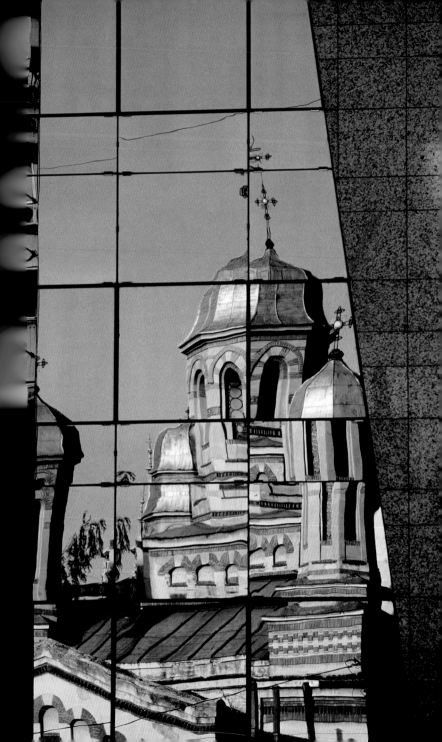

REFLECTIONS

Reflections abound in the urban landscape and seeking them out is great fun. Windows, mirrors, wet streets, puddles of water, rivers, water features and the highly reflective building materials used on building exteriors provide the perfect surface for creating images as diverse as picture-perfect postcards and intriguing abstractions of reality.

Reflections in rivers and water features are at their best when the air is still and the buildings around them are receiving strong, direct light, which is usually early or late in the day or when they are lit by incandescent lighting. Reflections in the glass walls of buildings vary in intensity throughout the day as the strength and direction of the light striking them and surrounding buildings varies.

When composing a reflected image, focus on the main subject, not the reflection. It's always worth taking a few minutes to assess the effect a polarising filter will have on the subject, as sometimes you'll be able to take two quite different pictures from the same viewpoint.

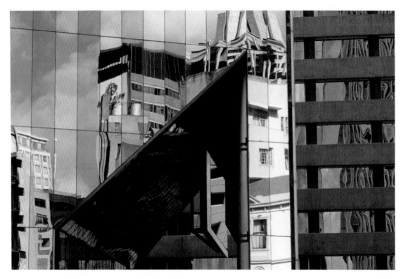

Reflections on Diagonal St, Johannesburg

It's easy to miss reflections on the surfaces of modern city buildings as you walk below them. The glass entrance to this building hinted at reflections, but it wasn't until I crossed the street and looked back that the potential revealed itself. Telephoto lenses usually work best to create tight compositions of the most interesting sections of the reflection.

▲ 35mm SLR, 100mm lens, 1/125 f11, Ektachrome E100VS

Reflected church, Santiago, Chile

◀ 35mm SLR, 180mm lens, 1/250 f8, Ektachrome E100VS

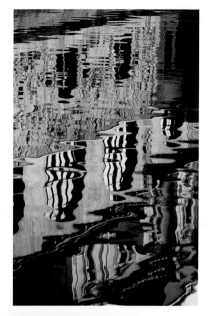

Plečnik Colonnade reflected in Ljubljanica River, Ljubljana, Slovenia

Rivers can produce everything from mirror-like reflections to totally abstract interpretations depending on the quality and strength of light on the subject and the stillness of the water. This semiabstract image may be recognisable to a local, but it was the different ripple effects on the water's surface that caught my eye.

▶ 35mm SLR, 80-200mm lens, 1/160 f11, Ektachrome E100VS

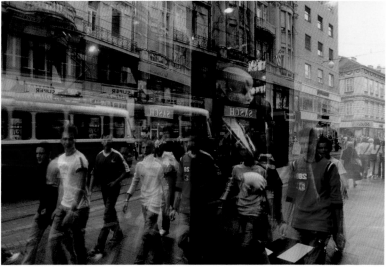

Reflections in shop window, Zagreb, Croatia

Although this looks like a multiple exposure, it's a single frame. The trick is to find a shop window that has an interesting display (in this case, the mannequin), is opposite interesting buildings (balconies and windows) on a street where something is happening (trams going past) and has plenty of pedestrian traffic (the group of boys). Success rates are higher if the light on all subjects is even.

▲ 35mm SLR, 24-70mm lens at 24mm, 1/125 f5.6, Ektachrome E100VS

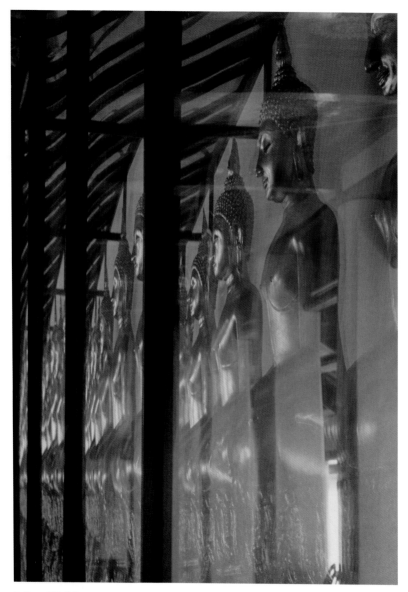

Reflected Buddha statues at Wat Saket, Bangkok, Thailand

There are lots of impressive rows of Buddha statues in the temples of Thailand, so the opportunity to take a slightly different picture was welcome. Unusually, these statues were in glass display cases, which produced an impressive reflection. I didn't use a polarising filter to eliminate the glare on the glass as it's not interfering with the point of interest and ensures viewers realise it's a reflected image.

▲ 35mm SLR, 50mm lens, 1/30 f11, Ektachrome E100VS, tripod

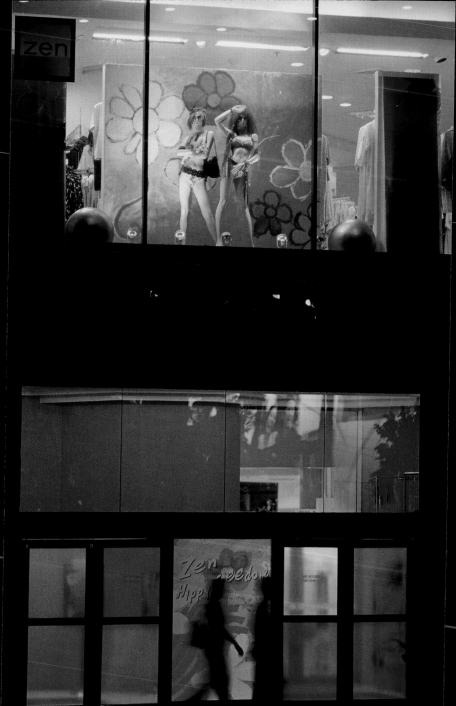

SHOPS

Shops probably don't leap to the top of most people's mind as riveting subject matter. However, shopping is a significant urban experience and shops take up a lot of space. In large complexes, central public spaces are often architecturally interesting and good vantage points are numerous. Window displays and shop interiors are created to be eye-catching, some are almost works of art, and they certainly make good subjects, especially when the product for sale is photogenic.

Unless you place your lens directly against the glass of a shop window, you'll usually find that you require a polarising filter (p19) to cut down the distracting reflections.

Window display in Emporium Shopping Centre, Bangkok, Thailand
On assignment in Bangkok, I had a list of a dozen shops in a large modern shopping complex to photograph for inclusion in a guide to the city. Only three gave permission on the spot, but I was able to fulfil my brief. The others wanted paperwork filled in and meetings to be held, for which I had no time (or patience).
▲ 35mm SLR, 35mm lens, 1/8 f11, Ektachrome E100VS, tripod

Shop interiors are often lit by a mix of light sources and using the available light often gives a pleasing result. If the light is too low to use your preferred sensor setting or film, you'll need to use a tripod, although they can be awkward in busy shops. Refrain from using a single flash as it destroys the ambience. To avoid these problems altogether, look for shops and displays that are well lit, especially those that have large windows, as the even light will allow you to capture the entire space while getting more detailed product shots quickly and easily.

It's common courtesy to seek permission to take pictures of window displays or shop interiors and it's certainly much easier to get the go-ahead in smaller, privately run businesses than it is in major-brand shops in modern shopping complexes. You can increase your chances of getting on-the-spot permission by buying something first, complimenting the staff on how fantastic the display is and making your request when the shop is quiet, often just after opening. Don't forget the possibility of creating an environmental portrait by asking the salesperson or owner if you can photograph them in their shop.

Shops at World Trade Centre, Bangkok, Thailand
◀ 35mm SLR, 100mm lens, 1/15 f2, Ektachrome E100VS, tripod

Be aware that in most modern shopping complexes you'll be approached very quickly by security people if you set up a tripod or spend too long with a professional-looking camera in one spot. They will not have the authority to give you permission to continue, so if you want to pursue the issue you'll end up in an office making an appointment to see the appropriate person.

Catholic Shop, Oaxaca, Mexico

If you need a life-size statue of a crucified Jesus, this is the shop for you. Actually, there are plenty of shops like this, but this one was filled with natural light so it took only a few seconds from seeing, to composing, exposing and leaving – just how I like it.

▲ 35mm SLR, 24mm lens, 1/60 f5.6, Ektachrome E100VS

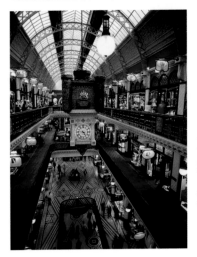

Queen Victoria Building, Sydney, Australia

The Queen Victoria shopping complex is a tourist attraction and consequently is photographed all the time. As there is good light from the glass roof, most people are satisfied with their pictures. But to shoot on the medium-format camera and achieve maximum depth of field, I needed time and a tripod. Therefore permission was required, as was my signature to say I was covered for $5 million if someone tripped over my tripod and was hurt.

◀ 6 x 7cm SLR, 45mm lens, 1/ f11, Ektachrome 100STZ, tripod

Carpet trader in shop, Peshawar, Pakistan

Buying a carpet is rarely just a commercial transaction. It usually involves a short history of local carpet-making traditions, lots of tea and much bargaining. In this case it even extended to dinner on the carpets. After all that you're usually not going to be declined the request to photograph your new best friend in his shop.

▶ 35mm SLR, 24mm lens, 1/15 f2, Kodachrome 200 rated at 400 ISO (1 stop push)

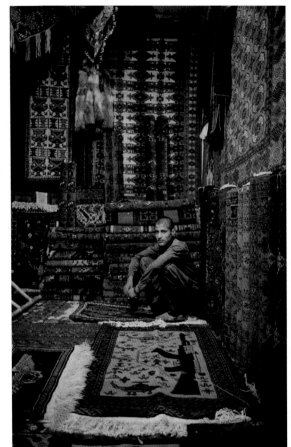

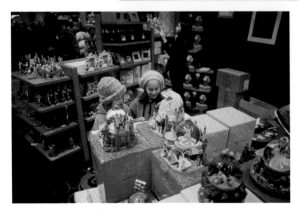

Young shoppers in the Disney Store, New York, USA

Always check to see if you can get away with using the available light inside shops, as your photos will benefit from the shop's even light levels, even if they are low. Here the items in the foreground, the shoppers and the display stands are all lit equally. Plus, you don't attract attention to yourself as you would using flash.

◀ 35mm SLR, 24mm lens, 1/30 f2, Ektachrome E100VS

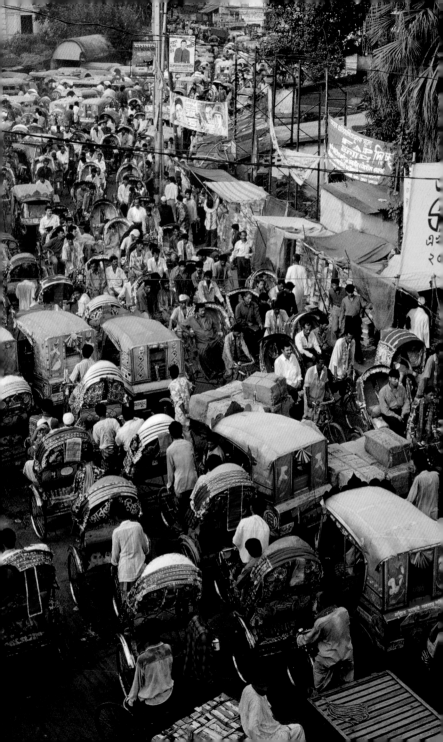

TRAFFIC & TRANSPORT

No pictorial coverage of the urban environment would be complete without images of vehicles plying the roads, waterways and tracks in and around town. Vehicles that are typical of a city, such as man-pulled rickshaws in Kolkata, three-wheeled *túk-túks* in Bangkok, harbour ferries in Sydney and cable cars in San Francisco, are all symbolic of their urban location.

Many big cities are infamous for their road-traffic congestion and the pollution it causes. It might be annoying as a pedestrian or passenger, but it's good value for the photographer.

The only way to really show congestion is from a high vantage point. Bridges and pedestrian overpasses are dotted across most major roads and are perfect for photography. Shooting in harsh light in the middle of the day will heighten the impression of an unattractive environment and clearly show the pollution. Shooting in the warm light of early evening, when the rear lights of vehicles are on, can make crowded roads seem much more attractive.

From your high vantage point, focus on a point some distance up the road with a 100–200mm telephoto lens or zoom and you'll compress the traffic, giving a much stronger impression of a busy road. Shooting with a tripod will also allow you to use slower shutter speeds to blur moving vehicles to great effect.

Back down at road level, you can illustrate the frenetic pace of the traffic by picking out individual vehicles and using the panning technique to keep the moving subject sharp while blurring the background, creating a sense of movement and speed. The speed at which the subject is moving will determine the shutter speed. Start with 1/30 and 1/15. Train your camera on your subject and follow it as it moves. As it draws level with you, press the shutter release and keep following the subject. The shutter must be fired while the camera is moving.

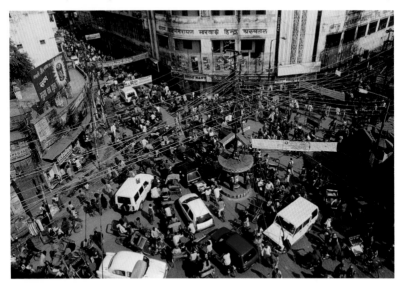

City intersection, Varanasi, India

At ground level it's pretty obvious that the junction of Dasawamedh Ghat and Mandapur Rds is a quintessential Indian city intersection – one of those that you'll never get across unless you just look straight ahead and walk, trusting that the drivers will avoid you just as they avoid each other. Shooting from a high vantage point overlooking the junction was the only way to capture the chaos.

▲ 35mm SLR, 24mm lens, 1/250 f8, Ektachrome E100SW

Auto & bicycle rickshaws, Dhaka, Bangladesh

◀ 35mm SLR, 35mm lens, 1/125 f5.6, Ektachrome E100VS

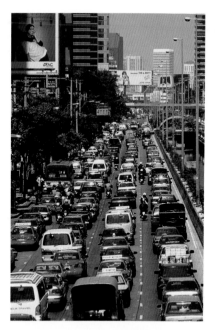

Traffic on Thanon Sathon Neua, Bangkok, Thailand

The harsh, clear light in the middle of a hot day isn't generally favoured for photography, but in this case it's ideal for portraying the grim reality of the traffic jam experienced by many on Bangkok's busy roads.

▶ 35mm SLR, 100mm lens, 1/125 f16, Ektachrome E100VS

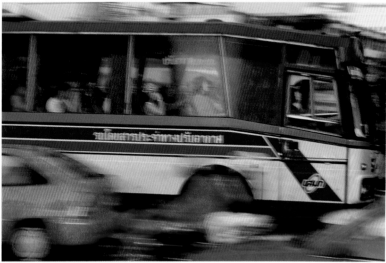

Traffic on Ratchaprarop Rd, Bangkok, Thailand

By focusing on a moving vehicle and panning (p115) to create a sense of movement, the traffic is still portrayed as chaotic but in a slightly more exciting and colourful way.

▲ 35mm SLR, 100mm lens, 1/30 f8, Ektachrome E100VS

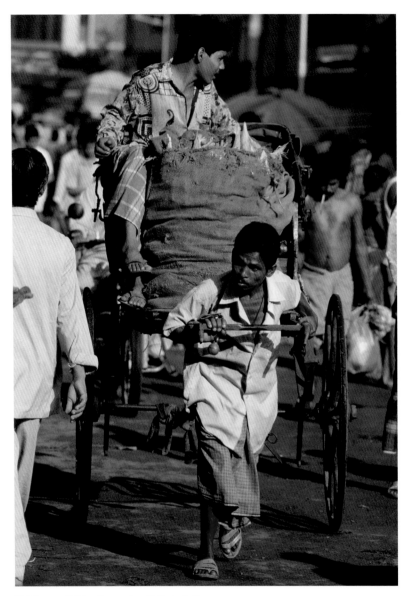

Rickshaw wallah leaving market, Kolkata, India

Rather than running around trying to get in front of moving vehicles, find a location that is obviously a popular route and wait for them to come to you. With a zoom lens you can reframe as they get closer and take a series of shots of each vehicle. Fixed-lens users will have to wait and fire off one or two frames when the vehicle reaches the place that fills the frame.

▲ 35mm SLR, 180mm lens, 1/250 f8, Ektachrome E100SW

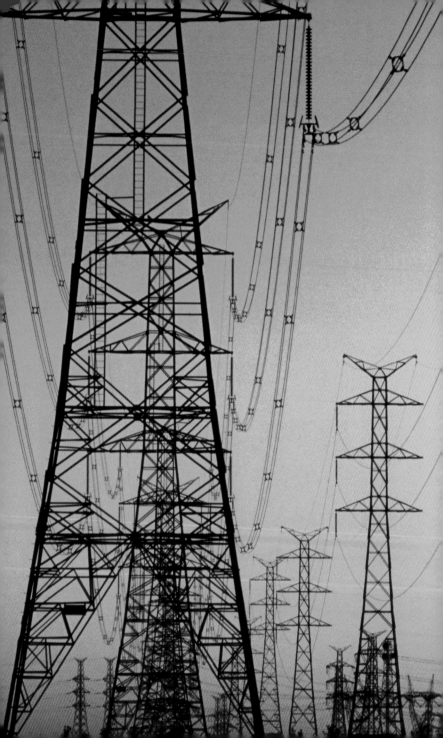

INDUSTRY

Most travellers don't experience much of a city's industry, except perhaps to drive through on the approach to the town from another place, the airport or railway station. But every city has an industrial area offering totally different subject matter to the normal urban environment experienced by the visitor.

Access can be limited and you'll often be confined to the perimeter of factories and ports, but many of the structures are large in scale and easy to photograph from a distance. Shoot industrial landscapes and subjects in the same warm light that you would skylines and architectural details and you'll make industry look surprisingly attractive.

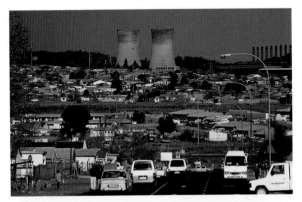

Highway & power-station chimneys, Soweto, South Africa

It only takes one distinctive element – in this case a couple of massive chimneys – to add an industrial edge to an image, particularly when it's the point of interest.

◄ 35mm SLR, 180mm lens, 1/250 f8, Ektachrome E100VS

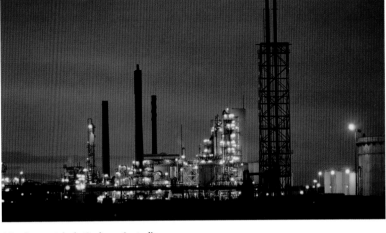

Oil refinery at dusk, Geelong, Australia

Apply all the same techniques to industrial subjects that you use when photographing skylines and architecture and you'll be able to make them look just as beautiful – in their own way.

▲ 35mm SLR, 180mm lens, 1/2 f11, Ektachrome E100SW, tripod

Electricity towers silhouetted at sunset, Melbourne, Australia

◄ 35mm SLR, 100mm lens, 1/30 f11, Ektachrome E100SW, tripod

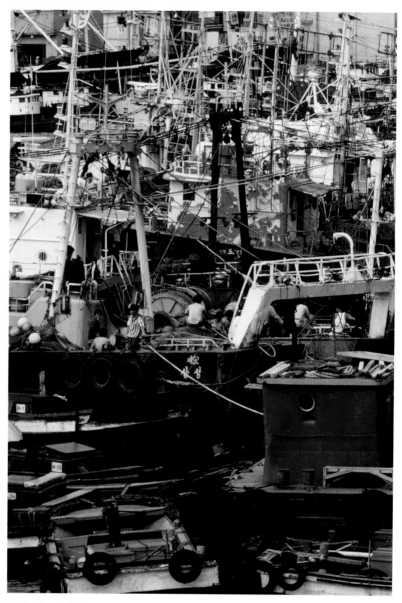

Fishing fleet in harbour, Busan, South Korea

The commercial fishing fleet in the port city of Busan was in a restricted area, but a high vantage point some distance away provided excellent views of the jumble of ships. A telephoto lens compressed the scene to enhance the impression of a big, busy port.

▲ 35mm SLR, 180mm lens, 1/250 f8, Kodachrome 64

Wheat silo detail, Williamstown, Australia

Industrial areas offer a whole new range of subject matter for frame-filling detail images. Many of the surfaces and textures will be familiar, but the scale of the details is often considerably larger than that seen in the urban environment on the streets. The six rungs on the ladder only hint at the massive size of the wheat silo.

▲ 35mm SLR, 100mm lens, 1/125 f11, Ektachrome E100SW

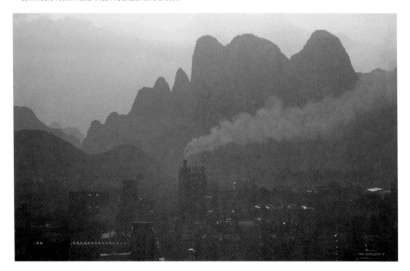

Smoke stack, Guìlín, China

This isn't how the famous karst mountains around Guìlín are usually portrayed, but from the roof of my hotel in the centre of town the proximity of the urban sprawl to the scenic beauty of the area was easy to see. Shooting into the sun increased the definition between the plume of smoke and the background, but the muted colours soften the overall impression of a heavily industrial area.

▲ 35mm SLR, 180mm lens, 1/250 f5.6, Ektachrome E100VS

CITY LIFE

Famous skylines, buildings and monuments may be the signature images of a city, but people are a city's heart and soul.

Cities have some obvious centres of human activity, such as city squares, marketplaces, restaurant precincts, shopping centres, places of worship and transport hubs, which are discussed separately as key subjects, but for a general introduction to life in the city, set off in any direction and you'll witness people from all walks of life going about their daily activities. Look to photograph them up close, at work, individually and in groups, posed and unposed. Each picture will add more depth to the impression of the city you're able to communicate through your photographs.

To shoot a variety of people pictures you'll need to employ both direct and candid techniques. Either way, for really good people pictures, you've got to be prepared to get close to your subjects. Except for crowd shots, standing at a distance with a long lens will rarely result in pleasing images, as you generally won't be able to fill the frame with your subject (unless you use a very long lens).

School children on street, Daocheng, China

With a group of about 300 school children fast approaching, I took up a slightly elevated position in their path (on a piece of broken concrete) so that I could pick out interesting individuals from the middle of the group. As they approached I zoomed out to keep them in frame until their expression and my composition came together.

▲ 35mm SLR, 80-200mm lens, 1/250 f5.6, Ektachrome E100VS

Rickshaw puller at Star Ferry terminal, Hong Kong, China

◄ 35mm SLR, 50mm lens, 1/125 f5.6, Ektachrome E100SW

For frame-filling portraits you'll need to approach individuals and seek their permission, as you will if you want to take a series of images of people, say of street performers or someone at work. You don't need to speak their language – simply holding the camera up usually makes it obvious what your intentions are. Study the light, think about your composition and make sure you've got the right lens on the camera before you approach your subject. Being organised and efficient means you'll minimise drawing attention to what you're doing, which will help your subject remain relaxed and will result in more natural-looking photos. The ideal focal-length for shooting portraits is between 80mm and 105mm, allowing you to fill the frame with a head-and-shoulder composition while working at a comfortable distance from your subject. For environmental portraits that include the location of the individual as an integral part of the composition, use focal lengths in the 24–35mm range.

Candid street photography is less confronting but equally challenging. It requires a quick eye and shutter finger, as the aim is to capture fleeting moments that you often can't anticipate.

Although the magic of the moment should take precedent over technical perfection, you can influence the outcome by finding an interesting location where there is a fair bit of activity and good light and then wait for things to happen around you. Candid people photography requires enormous patience, but if you're prepared to pound the streets in equal parts to standing around you'll be rewarded with distinctive pictures, as long as you remember rule number one – don't hesitate. Fleeting moments are just that, fleeting. Hesitate in releasing the shutter and the image is gone forever.

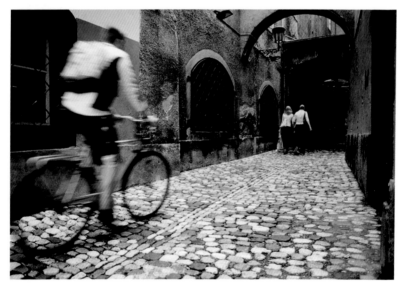

Passage off Ribji trg (Fish Sq), Ljubljana, Slovenia
This cobblestone passage is architecturally interesting but I wanted to show it being used, particularly by a cyclist, as I'd seen them speeding through while I was having lunch nearby. The low viewpoint and wide-angle lens created a pleasing composition (though it was a bit hard on the knees) and then it was just a matter of waiting (and waiting) for the right subjects to come along. The selected shutter speed blurred the cyclist slightly, adding a nice dynamic element to the image.
▲ 35mm SLR, 24-70mm lens at 24mm, 1/60 f4, Ektachrome E100VS

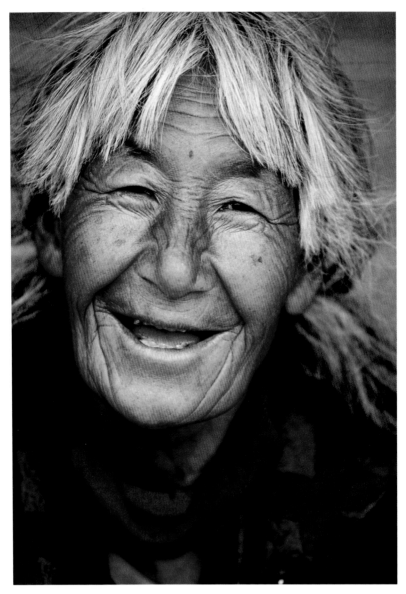

Portrait of Tibetan man, Daocheng, China
You'll see lots of interesting characters as you walk the streets, but there is often something not quite right. However, when the light is perfect you must act then and there, because the chance of a person being there later or you remembering to go back, is slim. Like this gentleman, most people are happy to be photographed if you approach them in a friendly and polite manner.

▲ 35mm SLR, 80-200mm lens at 100mm, 1/250 f5.6, Ektachrome E100VS

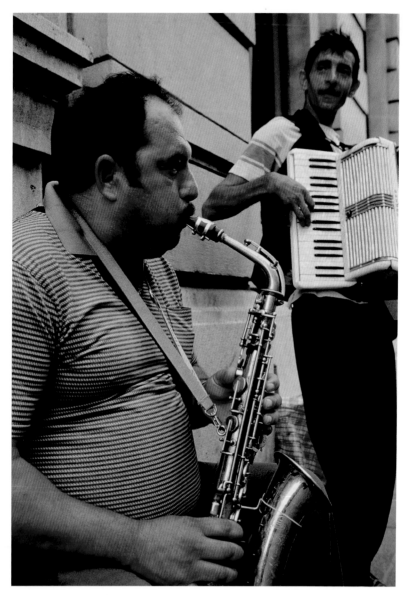

Street musicians, Zagreb, Croatia

I noticed these guys were moving around to different venues during the day, so I approached them immediately when they finally started playing in a spot with a background I was happy with and in good light. I always let people know I'll be taking a series of shots (language permitting) so they're not surprised when I start moving around them. And, of course, I always contribute generously to the hat.

▲ 35mm SLR, 24-70mm lens at 24mm, 1/60 f8, Ektachrome E100VS

Washing clothes at Mahalaxmi Dhobi Ghat, Mumbai, India
With around 5000 men washing clothes in open-air troughs, the Mahalaxmi Dhobi Ghat is a fascinating sight. There's a great overview from a bridge but getting down among the washing is the way to go. An entry fee is payable, of course, but at least then you know you're welcome and can concentrate on taking pictures.
▲ 35mm SLR, 24-70mm lens at 24mm, 1/30 f11, Ektachrome E100VS

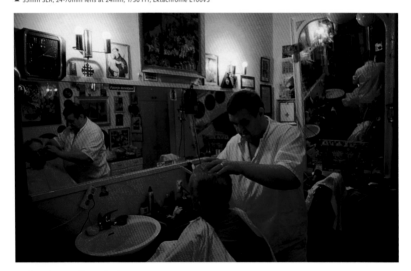

Barber shop, Dubrovnik, Croatia
After coming across this character-filled barber shop, I put it on my 'to do' list and walked past it regularly until the barber was busy with a customer. Using a wide-angle setting on my zoom, there was just enough light to work with my standard film. With mirrors everywhere, I was able to compose an environmental portrait that took in much more than just what was in front of the lens. My main concern was not capturing myself in a reflection.
▲ 35mm SLR, 24-70mm lens, 1/40 f2.8, Ektachrome E100VS

CITY SQUARES & PLAZAS

If you really don't know where to start when you arrive in a new place or are at a loose end for an hour or a day, you could do much worse than head to the city or town square. They're often the focus of daily life, a transport hub and a magnet for visitors. Typically lined with cafés, shops, impressive public buildings, places of worship and decorated with statues and fountains, they're a place for social gatherings, demonstrations and markets. Find a spot somewhere central and hang out like the locals until something catches your eye.

Naxi women, Lìjiāng, China

Any town square is worth visiting several times a day, as unplanned things can happen at any time. In this case, a large group of traditionally dressed women from the Naxi minority gathered and performed a dance. The strong mid-afternoon sunlight cast harsh shadows and the women were dancing in and out of a shaded area, so I concentrated on creating a tight composition and waited until the most interesting-looking person moved into frame.

◀ 35mm SLR, 24-70mm lens, 1/160 f11, Ektachrome E100VS

Trafalgar Sq, London, England
Taken in the middle of the day to capture the crowds, rather than in beautiful light, the square's hustle and bustle is further enhanced by using a telephoto lens to compress the various elements of the composition.
▲ 35mm SLR, 180mm lens, 1/250 f11, Ektachrome E100SW

Trg Josip Jelačića at dusk, Zagreb, Croatia
◀ 35mm SLR, 24-70mm lens, 2 secs f11, Ektachrome E100VS, tripod

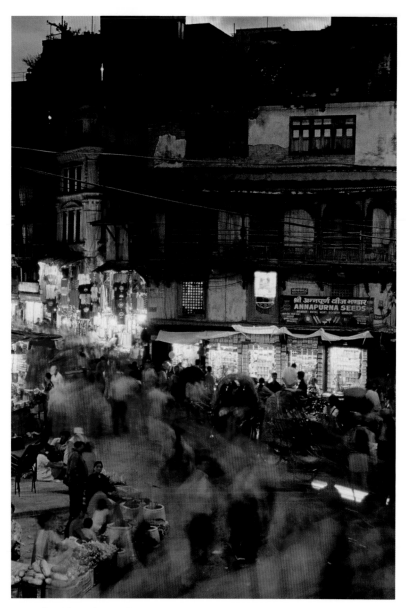

Asan Tole, Kathmandu, Nepal

In the heart of old Kathmandu, Asan Tole is a focal point of activity day and night, and a thoroughfare for vehicular and pedestrian traffic. To portray this sense of constant activity, I used a long shutter speed to blur movement around the fixed stalls and shops.

▲ 35mm SLR, 24-70mm lens, 4 secs f8, Ektachrome E100VS, tripod

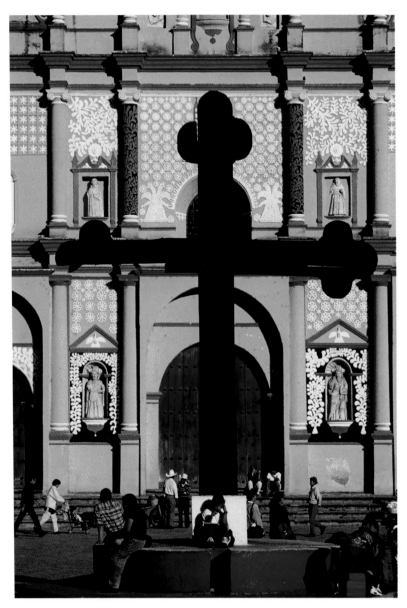

Cross in town plaza, San Cristóbal de Las Casas, Mexico
Cathedrals and other impressive public buildings often overlook plazas, providing the opportunity to include a human element against an impressive architectural backdrop. In San Cristóbal a massive black wooden cross provides an additional point of interest.

▲ 35mm SLR, 100mm lens, 1/125 f8, Ektachrome E100VS

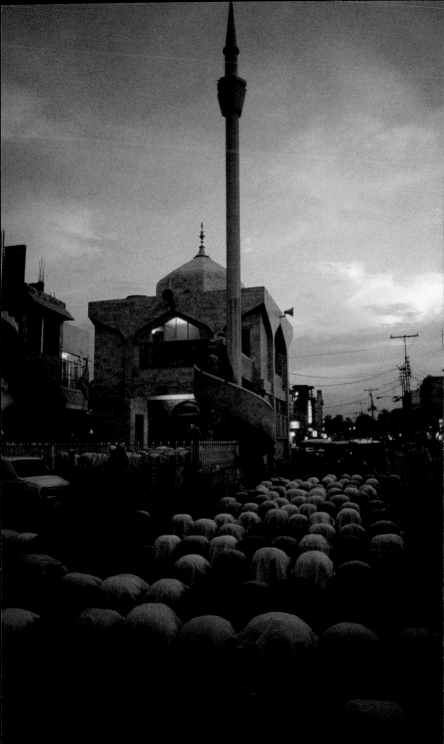

PLACES OF WORSHIP

Monasteries, temples, churches, mosques, shrines and synagogues are rich in subject matter and will give you the opportunity to photograph many of the same subjects you've already shot around town but linked by a common religious theme and within the confines of a single place. The buildings are often architecturally impressive, inside and out, and many contain fabulous works of art or at least ornate altars, painted ceilings and walls, statues of all sizes and stained-glass windows. There are also plenty of interesting details to discover, such as burning candles, incense coils, religious texts and motifs on walls. Because they're the focus of daily life, there is activity in and around the place much of the time, including stalls selling religious paraphernalia, souvenirs and flowers. This activity, of course, culminates at times of worship and special events.

Ideally, you need to make time for two trips to places of worship. Firstly, go when the place is quiet so you have the time and space to photograph the interior architecture and artworks. The interiors are usually dimly lit so a tripod is needed, and it's considerably more practical to take these pictures when there is no formal activity. Secondly, go at a time of worship, to capture the real spirit of the place, when it's functioning as a focal point for people's faith.

Monks at morning prayers at Wat Pho, Bangkok, Thailand
Having photographed morning prayers at Wat Pho before, I went prepared to take this shot. The previous time I was forced to use fast film, this time I took my tripod. The monks at the back of the hall were sitting close enough to the entrance to be lit by low-level natural light. They were also close enough to be photographed through a doorway, so my presence went unnoticed.
▲ 35mm SLR, 100mm lens, 1/15 f5.6, Ektachrome E100VS, tripod

Evening prayers at mosque, Peshawar, Pakistan
◀ 35mm SLR, 35mm lens, 1/30 f2, Kodachrome 200

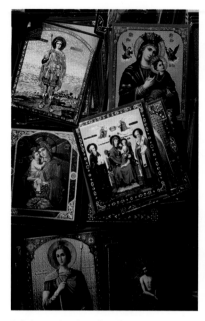

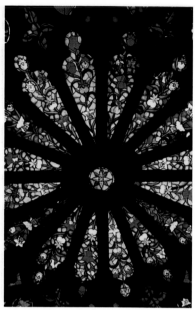

Religious prints for sale at Patriarchal Cathedral, Bucharest, Romania

Several stalls were set up with attractive displays, but only one had light falling on it in just the right way to give this simple composition the lift I was looking for.

▲ 35mm SLR, 24-70mm lens, 1/125 f6.3, Ektachrome E100VS

Stained-glass window in the Church of La Basilica, Quito, Ecuador

Bright, overcast weather provides the perfect light to capture the details of stained glass, particularly when you're photographing a large area of glass. If there is a bright spot, it's best to select a portion of the window where the light is even. Exposures are usually straightforward, but if there's very dark and very light glass in your composition it's worth bracketing half a stop under, half a stop over and one stop over to ensure you reveal the detail in the different densities of glass.

▲ 35mm SLR, 50mm lens, 1/60 f5.6, Ektachrome E100VS

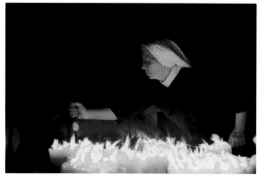

Nun attending candles at Stone Gate shrine, Zagreb, Croatia

Thirty minutes before I took this picture, the shrine was deserted, so I left. Fortunately, I went back to find it alive with people offering prayers and lighting candles. With so many candles, it was possible to work with the available light. Spot-metering on the nun's face solved the light-metering problem created by the extreme contrast between the burning candles and the dark background.

◄ 35mm SLR, 24-70mm lens, 1/80 f6.3, Ektachrome E100VS

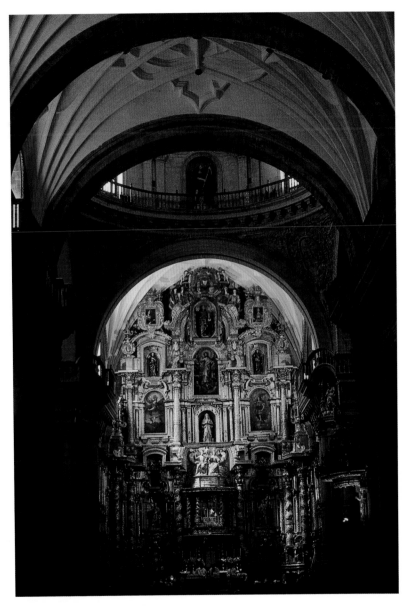

La Compañía Cathedral, Cuzco, Peru

The low, atmospheric light levels in the cathedral demanded the use of a long shutter speed and therefore a tripod, particularly as I wanted to go for a big, wide shot to capture the impressive vaulted ceiling along with the altar. As the composition's main point of interest, the light on the altar determined the exposure.

▲ 35mm SLR, 24mm lens, 1 sec f8, Kodachrome 64, tripod

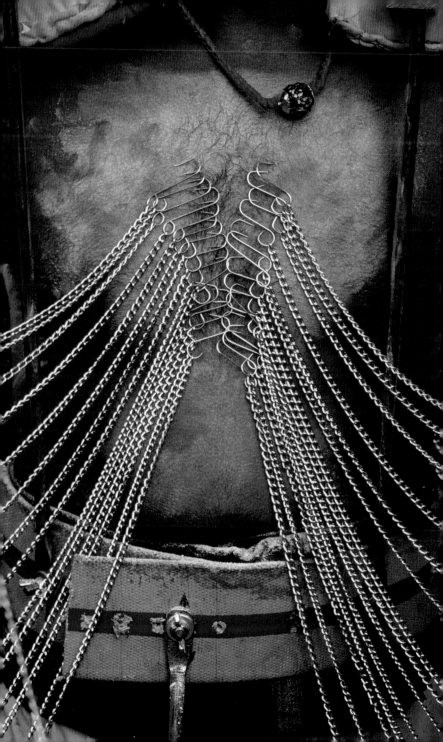

FESTIVALS

Festivals offer the chance to see a completely different side to a city and its inhabitants. The streets and squares are transformed as large, colourful crowds gather to participate in or watch the action. Many people dress up for the event, either in their best clothes, traditional dress or just for fun in whacky gear, and they're very happy to be photographed.

Festivals in urban areas can be particularly intense as they attract large crowds into finite spaces, hemmed in by buildings and roads. Crowd control is obviously an issue and getting close to the action can't be guaranteed. Arrive in the vicinity early for the chance to get your bearings of the area, check out possible vantage points and confirm basic facts such as start and finish times and the duration of the event.

If the event involves a procession, consider the direction of the sun and the background possibilities before you take up a position. If your movement is restricted, infuse variety into your shots by varying focal lengths and framing horizontally and vertically. If you're able to move around, plan to shoot from at least two different spots: one at street level and the other from an elevated position. For more informal shots and great opportunities to get really close, seek out meeting places where the participants gather before and after the parade.

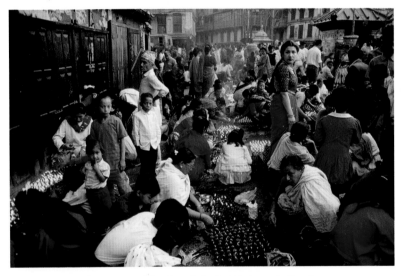

Lighting candles during Seto Machhendranath Festival, Kathmandu, Nepal

The main event may be what attracted you to the festival, but often the activity on the periphery is just as interesting and can add another dimension to your coverage. After a day photographing the chaos that goes with pulling massive chariots through the narrow streets of old Kathmandu, I captured a much more serene side of the festival as people gathered in the early evening to light candles and make offerings to the god being honoured.

▲ 35mm SLR, 24mm lens, 1/30 f2, Kodachrome 200

Detail of devotee at Thaipussam Festival, Singapore
◀ 35mm SLR, 100mm lens, 1/125 f5.6, Kodachrome 200

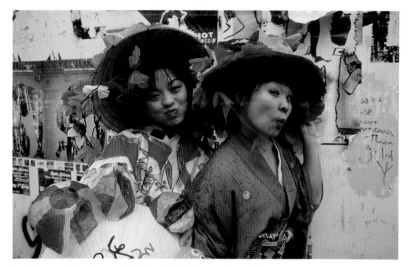

Participants in the Brunswick St Festival, Melbourne, Australia

▲ 35mm SLR, 24mm lens, 1/125 f5.6, Ektachrome E100VS

Festivals provide great opportunities to photograph people, as they are often dressed up and in party mode and it's quite easy to get them to stop for a picture. Be on your toes because the atmosphere encourages people to play up for your camera. Spend enough time and you'll see lots of interesting subjects, including visual extremes such as a woman in hill-tribe finery and a man smeared in white powder with a bucket on his head.

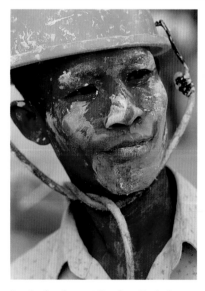

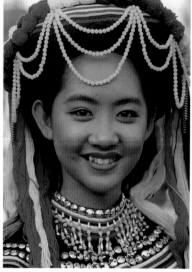

Powder-faced man at Songkran Festival, Bangkok, Thailand

▲ 35mm SLR, 100mm lens, 1/125 f5.6, Ektachrome E100VS

Young woman at Songkran Festival, Bangkok, Thailand

▲ 35mm SLR, 100mm lens, 1/125 f5.6, Ektachrome E100VS

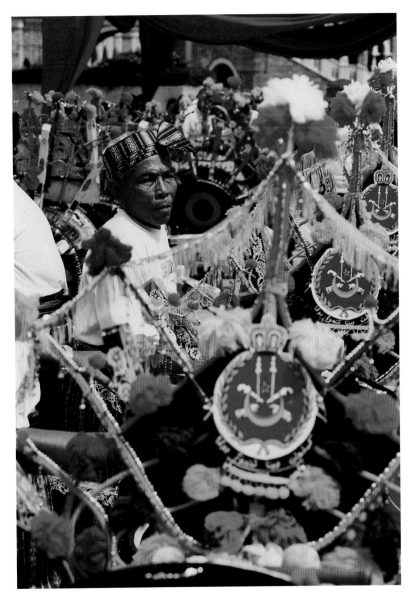

Drum Festival, Kuala Lumpur, Malaysia

Sometimes you can just be lucky and come across an event you didn't know about, as I did with this gathering of drummers in KL. It's for experiences such as this that you should always carry additional film, memory cards and batteries, because you can use a day's quota in a couple of hours if the event is as colourful and interesting as this was.

▲ 35mm SLR, 100mm lens, 1/125 f11, Ektachrome E100SW

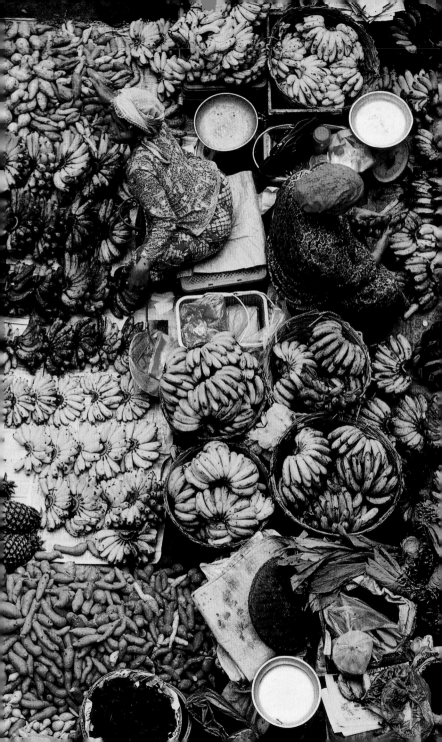

MARKETS

Markets add vibrancy and colour to the urban environment and they'll do the same for your photo collection. An integral part of daily life for residents, they offer a wealth of photo opportunities for the photographer trying to evoke the character of the city. Search out the most interesting stalls, especially those displaying produce, food, craft and souvenirs that are unique to the city or country. Wait nearby for the customers to come and go; you'll be less obvious and better placed to capture candid moments than if you dash from one stall to another as you see things happening. Get there early so you're shooting in the best light. For a complete market coverage, aim to take a variety of shots: an overview from a high vantage point; traders at their stalls, handling the produce and serving customers; portraits of traders; and close-ups of the products for sale.

Traders at the Italian Market, Philadelphia, USA

Unless you're taking frame-filling portraits, photographs of the traders at markets work best if you show them at work. When you're this close to the action, it's best to gain permission to shoot and then wait until your subject's attention returns to serving the customer.

▲ 35mm SLR, 24mm lens, 1/60 f2, Ektachrome E100VS

Traders on market stalls, Kota Bharu, Malaysia

◀ 35mm SLR, 100mm lens, 1/125 f2, Kodachrome 200

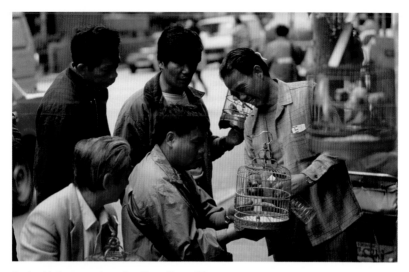

Buying birds at a street market, Hong Kong, China

Having located an interesting and well-lit part of the market, I confirmed it was OK to take photos with a couple of the traders, and then took a whole series of pictures over the next half-hour. Unless you get in the way, people soon go back to their business, but the initial contact means you don't keep attracting their attention and your presence is accepted.

▲ 35mm SLR, 100mm lens, 1/125 f4, Kodachrome 200

Hauling bags of rice at Sadarghat Market, Dhaka, Bangladesh

The colour and spectacle of the market might be in and around the stalls, but take time to check out the back of the market, where the goods arrive, are unpacked and loaded onto transport. This is where you'll see lots of action and people who don't see as many cameras as the traders on the stalls.

▲ 35mm SLR, 24mm lens, 1/125 f2, Ektachrome E100VS

Bags of lavender at a market on place aux Aires, Grasse, France

▲ 35mm SLR, 24-70mm lens, 1/125 f5.6, Ektachrome E100VS

Sombreros at Centro de Artesanías La Ciudadela Market, Mexico City, Mexico

▲ 35mm SLR, 100mm lens, 1/125 f4, Ektachrome E100VS

Close-ups of the goods for sale make interesting, colourful and often graphic images. Look particularly for items that are symbolic of the region or country. They don't come any more symbolic (or obvious) than lavender in Provence, Mexican sombreros and Guatemalan cloth.

Shawls at Sunday market, Chichicastenango, Guatemala

▲ 35mm SLR, 100mm lens, 1/125 f5.6, Ektachrome E100VS

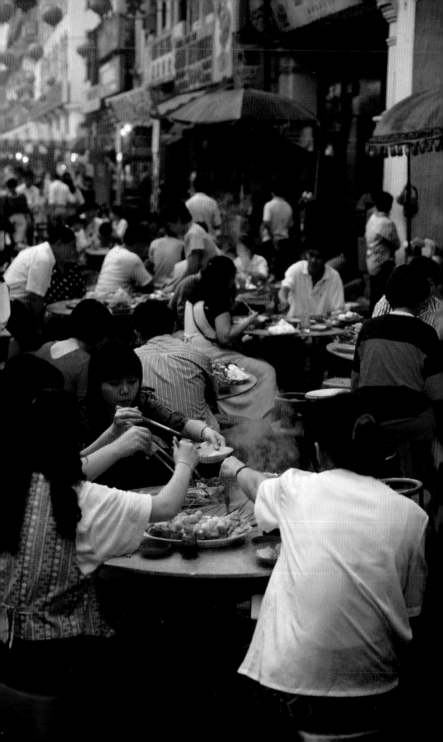

CAFÉS, BARS & RESTAURANTS

Cafés, bars and restaurants, particularly those with outdoor seating, add greatly to the atmosphere of a city, but that's only when they're busy. Photographs of a café full of empty tables and chairs tell us nothing except that you were there at the wrong time. Cafés, bars and restaurants are gathering places so they should be portrayed as such, unless your aim is purely architectural.

For interiors it's best to get the permission of a staff member, as you'll probably need to use a tripod or camera support – a quick snap will rarely come off. Outdoors you can approach photography in a couple of ways. Take a seat, order a drink and discreetly photograph the other customers and you'll be a lot less conspicuous than if you stand around in front of the patrons. Even so, you'll nearly always be seen, which is embarrassing. Plus, the chance of being able to compose the perfect shot with the right light will be limited from your seat. It's much better to identify one or two people you'd like to photograph and seek their permission. A wide-angle lens will let you work close to the people you're photographing and include part of the café and other customers in the background, which is ideal in crowded places. Alternatively, use a 100–150mm telephoto or zoom lens to isolate one or two people. Make this decision before you approach your subjects so that you can work fast.

Customer at street café, Zagreb, Croatia

One of six gentlemen around a table at an outdoor café, this man had a few questions about why I wanted to photograph them, but quickly gave the OK. Often the hardest thing about taking these pictures is approaching people and asking permission. Once they've agreed, which is nearly always the case, the trick is to get them to go back to what they were doing, so your pictures look more candid than posed.

▲ 35mm SLR, 24-70mm lens, 1/90 f4, Ektachrome E100VS

Diners at night food market, Kuala Lumpur, Malaysia

◀ 35mm SLR, 50mm lens, 1/60 f4, Ektachrome E100SW

Customers at street café, Ljubljana, Slovenia

Even with a telephoto lens it's hard to take pictures like this without being seen. Plus, I'm much more comfortable asking permission than I am getting caught sneaking pictures from a distance. However, having gained permission I stepped back and used a medium telephoto setting on my zoom to give the feel of a candid shot and get a close-up without crowding the two women.

▲ 35mm SLR, 80-200mm lens at 135mm, 1/180 f4.5, Ektachrome E100VS

Café interior, Ljubljana, Slovenia

I try to balance professional photographic techniques with a practical approach. Rather than set up a tripod and run the risk of extended questioning about what I was doing, I opted to support the camera on my camera bag and used a cable release to eliminate camera shake. More often than not though, people want to help. In this case the barman turned the lights up without being asked.

▲ 35mm SLR, 24-70mm lens at 24mm, 1/3 f4, Ektachrome E100VS

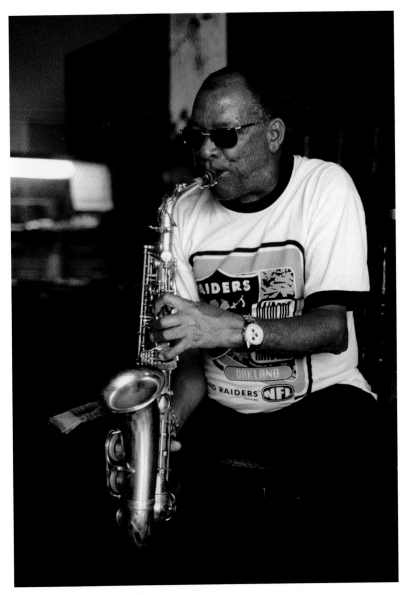

Musician performing in bar, Cienfuegos, Cuba

Where there's music there's pictures. And the combination of the two doesn't come any better than on a quiet Sunday afternoon in a Cuban bar. Before getting comfortable though, check what time the music stops; you may have arrived just in time to hear the last song, and then you'll have to forgo the drink and get shooting – quickly!

▲ 35mm SLR, 50mm lens, 1/60 f2, Ektachrome E200 rated at 800 ISO (2 stop push)

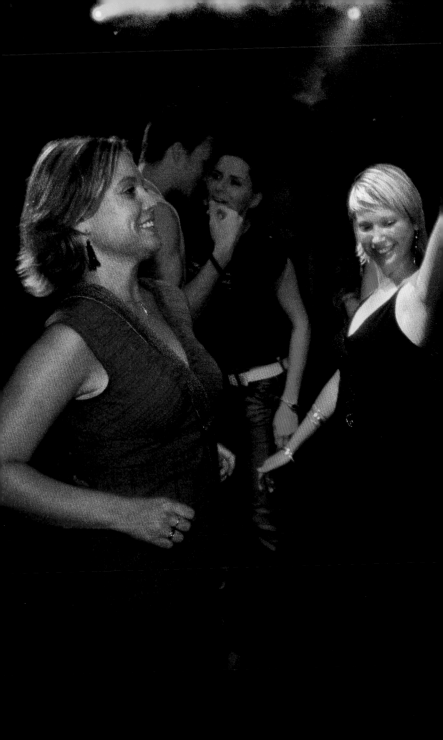

NIGHTLIFE

From around 8pm every night you can try your hand at capturing the city's nightlife. Live music, cultural shows, the bar scene and crowded nightclub dance floors will keep you busy well into the early hours of the morning.

At cultural shows you may be restricted to your seat, so take along your full set of lenses. Avoid using direct flash as it will kill the ambience of the venue and performance. Instead use the available incandescent light or combine it with flashlight.

Mixing incandescent and flashlight works well at shows where there is movement on stage and you're able to get within the range of your flash unit. Interesting pictures often result and you're able to use your preferred sensor setting or fine-grain film. The flash can be aimed directly at the subject or bounced using an accessory reflector or off the ceiling, if it's low enough and of a light colour. Select a slow shutter speed or night mode (available on many cameras) as if exposing for the ambient light. Any movement by your subject is captured through the blur caused by the slow shutter speed, but the action is stopped and the subject rendered sharp at the moment the flash is fired. This is known as the flash-blur technique.

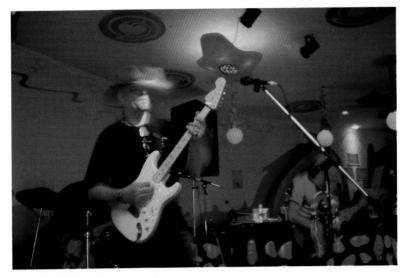

Rock band performing in bar, Bangkok, Thailand
Even in a small bar there can be enough light to use fast film or sensor settings to take pictures without flash. The orange cast caused by using daylight film in incandescent light enhances the stage lighting. I always seek permission from the manager to take pictures, either during the day or early in the evening, before they get too busy. Otherwise I run the risk of being refused and having to spend my time looking for other venues when I should be taking pictures.
▲ 35mm SLR, 35mm lens, 1/30 f4, Ektachrome E200 rated at 400 ISO (1 stop push)

Dancing at Globe Nightclub, Ljubljana, Slovenia
◀ 35mm SLR, 24-70mm lens, 1/30 f5.6, Ektachrome E200 rated at 800 ISO (2 stop push), flash

If you choose to work with the available light, fast 400 or 800 ISO film or an equivalent digital-sensor setting will usually allow you to hand-hold your camera at shutter speeds of 1/30 or 1/60 of a second, particularly if you've got image-stabiliser lenses (p16). Study the lighting carefully. Stages and performers are rarely lit evenly. Usually the performer is lit by a spotlight and is much brighter than the background. Unless the performer fills the frame, automatic meters will overexpose the subject. This is the ideal situation to use your camera's spot-metering system. Alternatively, zoom in and fill the frame with the spotlit performer, lock the exposure and recompose, or underexpose the meter's recommendation by one or two stops.

With or without the aid of flash, time your exposures for the moments when the lights are at their brightest to minimise large areas of shadow behind your subject.

Achieving good pictures in bars and nightclubs is hard work. Most venues are crowded and have low light levels. If you intend to take any more than one or two quick shots, you're best advised to seek permission from the manager. They very rarely say no and usually go out of their way to help, introducing you to the security guys, bar staff and band members.

Keep your equipment simple. A small shoulder bag with one camera and your fastest zoom or fixed wide-angle lens and flash unit is all you'll need. It makes working in crowded spaces much more comfortable for you and the venue's patrons.

Experimentation is the key in all these situations, so be prepared to take plenty of frames. Digital users will really appreciate the instant feedback on the LCD screen.

Jazz band performing at the Troubadour, Dubrovnik, Croatia

This jazz band was playing outdoors on a summer night, creating a great atmosphere for the patrons and a challenge for the photographer: the main light source was the circular pink fluorescent tube around the business-name board. To create this effect I selected a slow shutter speed, filled the frame with the light, released the shutter, moved the camera in a circular motion (to create circles of colour on the film) for about one second, then zoomed out and recomposed to include the musicians before the flash fired, which I bounced into the white awning hanging over the stage area.

▲ 35mm SLR, 24-70mm lens, 2 secs f5.6, Ektachrome E100VS, flash

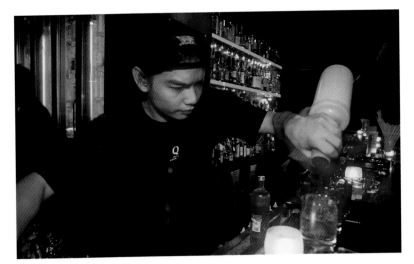

Barman at Q Bar, Bangkok, Thailand

In dimly lit bars the best opportunities are around the bar, which is usually illuminated and often a distinctive feature of the establishment. I took up a position on the corner of the bar where this barman made his cocktails and waited for the orders to pour in. Like many bars, this place was very dark and there was no option but to use flash. I exposed for the display of bottles and bounced the flash into a gold reflector so that the light was warm and realistic for the situation.

▲ 35mm SLR, 24mm lens, 1/15 f4, Ektachrome E100VS, flash

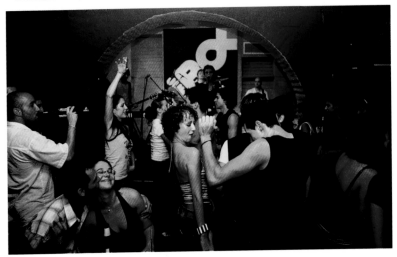

Band & patrons at the Juke Box Bar, Bucharest, Romania

In this small basement bar I was able to bounce the flash off the low ceiling to get an even light on the patrons in the foreground, which balanced nicely with the room and stage lighting. This wide shot works because the light is even and there are no large shadow areas.

▲ 35mm SLR, 24-70mm lens, 1/30 f4, Ektachrome E100VS, flash

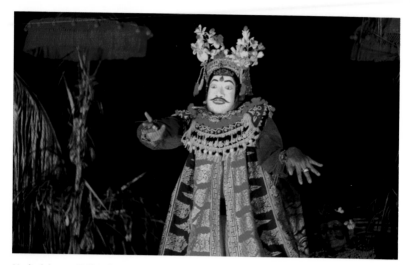

Masked dancer, Bali, Indonesia

The night sky provided an absolutely black background for the outdoor stage, but the spotlights on the performer were bright enough to use fast film. If you don't have spot-metering, zoom in and fill the frame with your subject, lock or note the exposure settings, then zoom out and recompose. The black background was put to good use by positioning the dancer against it, eliminating all distractions from around the mask and headwear.

▲ 35mm SLR, 100mm lens, 1/125 f2, Ektachrome E100SW rate at 400 ISO (2 stop push)

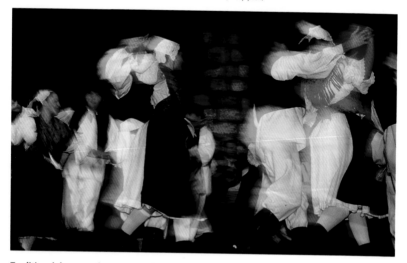

Traditional dance performance, Dubrovnik, Croatia

Confined to my seat in the fourth row from the front of a very crowded hall devoid of even a hint of artistic atmosphere, I used my zoom lens and the flash-blur technique (p149) to make the most interesting pictures I could in a pretty uninspiring location.

▲ 35mm SLR, 80-200mm lens, 1/30 f4, Ektachrome E100VS, image stabiliser, flash

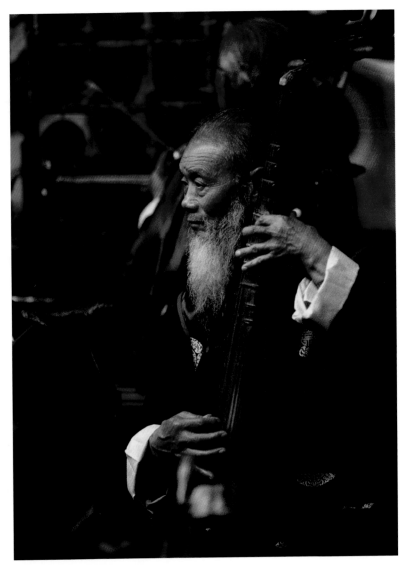

Musician in Naxi Orchestra, Lijiang, China

Every night the Naxi Orchestra plays traditional music in a beautiful old theatre. It's very relaxed, there are wide passages around the seating area and attractive stage lighting. Being able to move around certainly makes creative photography easier, but the technical challenges remain the same, as my preference is to use the available light to portray the atmosphere of the setting. Confidence using fast film (or high sensor settings) and image-stabiliser lenses (p16) are crucial to a successful result.

▲ 35mm SLR, 80-200mm lens at 200mm, 1/100 f2.8, Ektachrome E200 rated at 400 ISO (1 stop push), image stabiliser

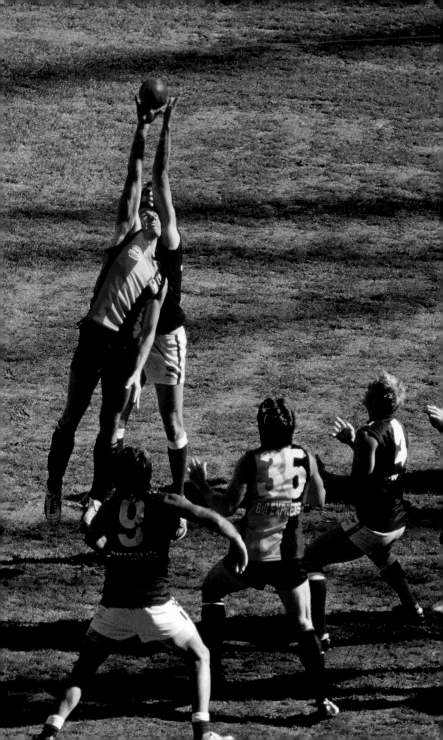

SPORTING EVENTS

Sport is an important part of the culture in many cities. Without accreditation, photographing big professional events is usually confined to the grandstands, so if you only have one opportunity to go to a game you'll have to make the most of the general access areas and the view from the seat you're given. This will often give you plenty of variety anyway, particularly if you view the photo opportunities as going beyond the field of play. Going to the biggest game in town is a cultural as well as sporting experience, so you'll have plenty to do even if you can't get as close to the action as you'd like. Look to capture crowd shots, spectator activity, traders selling sports paraphernalia and the stadium itself.

For close-up action go to less important or lower-grade games where access to the fence or boundary is much easier.

To photograph the players in action you'll need a long telephoto lens, ideally around 300mm. Even so, on large fields you won't be able to photograph a lot of the play so wait until the action comes within range and shoot quickly – you'll only get a few chances during the course of the game. Use film or select a sensor setting that allows a minimum shutter speed of 1/250 but ideally 1/500 to freeze the action.

Supporters at Australian Rules football match, Melbourne, Australia
▲ 35mm SLR, 300mm lens, 1/500 f6.3, Ektachrome E100VS

Two takes of the same game: the playing action and the supporters. Both pictures were taken from the second level of the stadium, which is not generally regarded as the ideal place to capture on-field action. However, with a long telephoto lens the high angle was put to good effect to create a more graphic sports image thanks to the uncluttered background and position of the players. Patience is a key factor, as very little of the play will occur exactly where you want it to. Crowd shots are more easily achieved, particularly when a team scores a goal and flags and banners are waved.

Australian Rules football match, Melbourne, Australia
◀ 35mm SLR, 300mm lens, 1/400 f8, Ektachrome E100VS

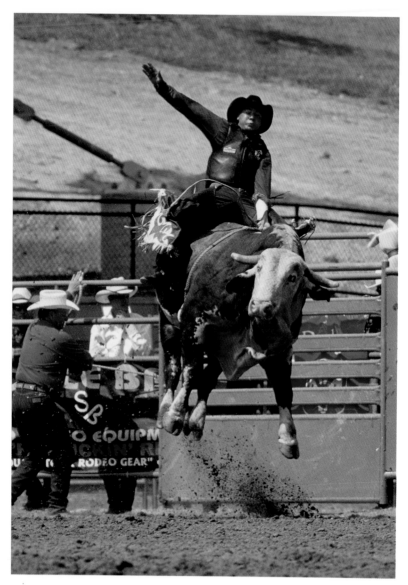

Cowboy riding bucking bull at rodeo, Springfield, USA

When the biggest rodeo in the world comes to town, even the most committed urban photographer shouldn't resist the temptation to capture a bit of country spirit. From a position directly opposite the entry gate, I could cover the action no matter which way the bulls and horses went. The action was fast and furious, with no time to think between frames, so I just set the fastest shutter speed the light allowed, kept the camera to my eye and fired away.

▲ 35mm SLR, 300mm lens, 1/1000 f5.6, Ektachrome E100VS

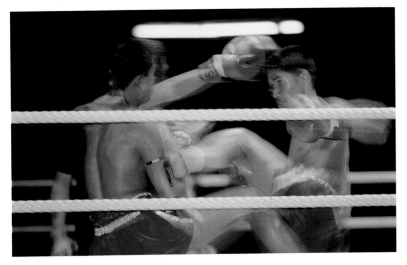

Kick-boxing match, Bangkok, Thailand

Photographing indoor sports at poorly lit arenas is yet another challenge. To freeze the action, fast film (up to 800 ISO) or sensor settings and fast lenses are required to gather as much light as possible. Or, if you can get close to the action, use the flash-blur technique (p149) with slower shutter speeds as I did here.

▲ 35mm SLR, 100mm lens, 1/30 f5.6, Ektachrome E100VS, flash

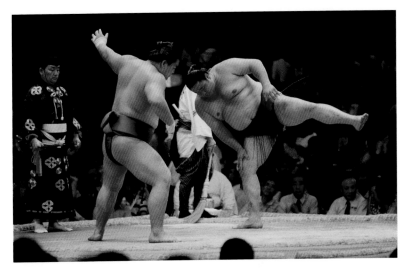

Warming up for a sumo wrestling bout, Nagoya, Japan

Flash would not have been appropriate at this event, even if I could get close enough to the ring for it to be effective. If events are broadcast on television, as sumo wrestling is, there's often sufficient light for still photography. Sports that are unique to the country are well worth the effort to get to and photograph, as the images offer just as strong an image of the country as its most famous architecture.

▲ 35mm SLR, 180mm lens, 1/250 f2.8, Kodachrome 200 rated at 400 ISO (1 stop push)

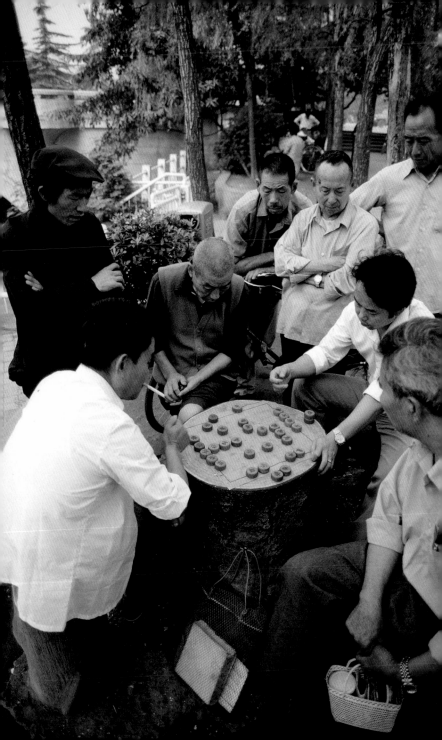

PARKS & GARDENS

Parks and gardens provide important recreational space for the residents of urban areas and a pleasant change of scenery for the city-bound photographer. Stroll through a park on a working day and you'll be surrounded by peace and serenity. Go back on a sunny weekend and you'll see a whole new side to the city as people converge for picnics, games, concerts, weddings, and other activities, or to simply people-watch.

Features such as conservatories, lakes and bridges, tearooms and bandstands attract visitors and offer a whole new set of backgrounds for the photographer to work with to depict a more relaxed side of city life.

Artist painting statue in Haw Par Villa Park, Singapore

Haw Par Villa Park is full of colourful and very kitsch statues depicting heroes and creatures from Chinese mythology. They are great subjects in their own right, but even more appealing was the opportunity to photograph the less common sight of an artist working on a statue.

◀ 35mm SLR, 24mm lens, 1/125 f8, Ektachrome E100SW

Conservatory in Botanic Gardens, Zagreb, Croatia
The run-down conservatory and clear proximity to a city street add an urban edge to this peaceful park scene.
▲ 35mm SLR, 80-200mm lens at 200, 1/250 f8, Ektachrome E100VS

Board game on Jǐn Jiāng riverbank, Chéngdū, China
◀ 35mm SLR, 35mm lens, 1/125 f5.6, Kodachrome 64

Men on bench in Cişmigiu Garden, Bucharest, Romania

The park benches fill up quickly on Sunday morning, so there are plenty of people to photograph, but only some of them will be in favourable light. As you walk around, study where the light is falling and be especially aware of shadows from overhanging branches on sunny days. Admittedly, this isn't all that easy to do without staring at people or drawing attention to yourself when you walk past 10 times, but it doesn't matter because they are there to people-watch and you're giving them someone to watch.

▲ 35mm SLR, 24-70mm lens at 24, 1/90 f6.3, Ektachrome E100VS

Kite flying in Sanam Luang (Royal Field), Bangkok, Thailand

This park sees kite flying on a massive scale, especially on festival days and public holidays. The concentration it takes to keep a kite aloft is evident on the faces of this mother and daughter team.

▲ 35mm SLR, 100mm lens, 1/125 f8, Ektachrome E100VS

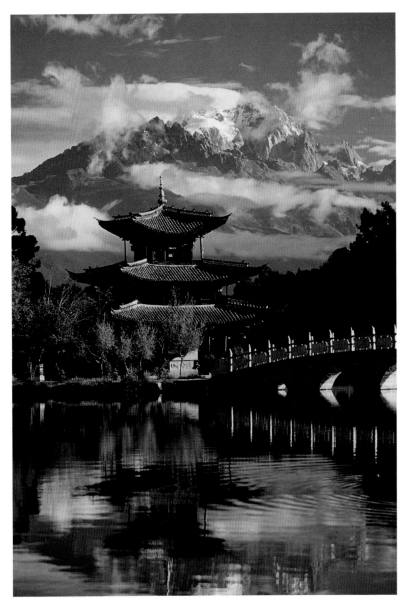

Black Dragon Pool Park, Lìjiāng, China

Parks often provide good vantage points overlooking cities, but this view of 5596m Mt Satseto (better known as Jade Dragon Snow Mountain) comes as quite a surprise given the park is in the middle of Lìjiāng's modern, sprawling city.

▲ 35mm SLR, 24-70mm lens, 1/20 f13, Ektachrome E100VS, polarising filter, tripod

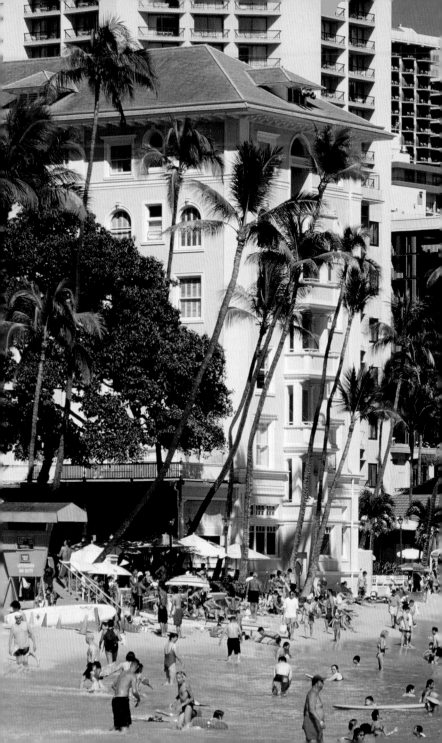

BEACHES

Beaches offer a recreational focus for many urban environments and many cities and towns owe their prominence to the stretch of sand and ocean on their doorstep. To make a connection with the urban environment and show the beach in relation to the city, find a vantage point that shows a sweep of beach backed by ocean-facing buildings. Piers and rocky headlands are ideal, otherwise you may have to walk into the water for the view.

An attractive general view of the beach showing lots of people should be straightforward enough, though in some countries beach security patrols or council officers may prevent you from taking any pictures, so work quickly and be prepared to move on if approached. You'll certainly draw attention to yourself if you stand around for too long in one spot with a big zoom lens on your camera. However, standing at a distance and trying to photograph individual people on the beach with a telephoto lens just doesn't work anyway. The pictures have a paparazzi look that isn't what good travel pictures should look like. Taking better pictures means seeking permission and creating images in the same way you take environmental portraits. If you're not comfortable approaching people who are lying on the beach, seek out those involved in beach-related activities: vendors selling souvenirs, ice creams, hats and sunscreen, and people playing games or building sandcastles.

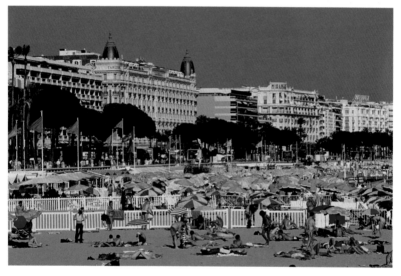

Beach & Blvd de la Croissette, Cannes, France

▲ 35mm SLR, 80-200mm lens, 1/400 f11, Ektachrome E100VS

With distinctive and famous buildings fronting the sea, Waikiki and Cannes beaches lend themselves perfectly to images that connect the beach with the urban environment.

Waikiki Beach, Hawaii, USA

◀ 35mm SLR, 180mm lens, 1/250 f8, Ektachrome E100VS

Lifesavers' tower & sunbathers on Waikiki Beach, Hawaii, USA

▲ 35mm SLR, 24mm lens, 1/250 f8, Ektachrome E100VS

Surfboards for hire on Waikiki Beach, Hawaii, USA

▲ 35mm SLR, 24mm lens, 1/250 f11, Ektachrome E100VS

There's a lot more to beaches than people lying on the sand, so explore them with a view to creating mini-photo essays or stories that capture various elements of a day at the beach.

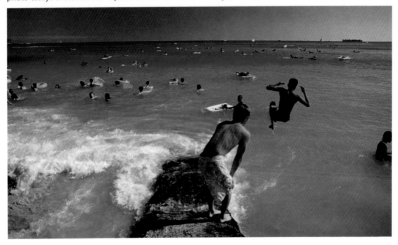

Boys jumping off wall at Waikiki Beach, Hawaii, USA

▲ 35mm SLR, 24mm lens, 1/500 f8, Ektachrome E100VS

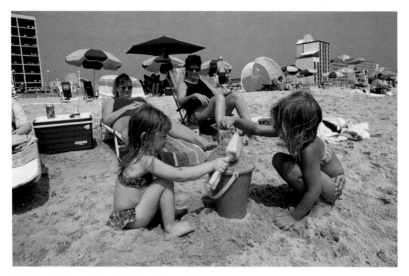

Children playing on beach, Virginia Beach, USA

The children were so engrossed with their bucket and spade they needed no encouragement to carry on as I photographed them. Because the sand was not dominating the frame, the camera's light meter handled the scene well. If bright sand is the dominant feature, it's best to overexpose by half a stop and one stop to ensure detail is retained in the other elements of the composition.

▲ 35mm SLR, 24mm lens, 1/125 f11, Ektachrome E100VS

Doing handstands on Galle Face Beach, Colombo, Sri Lanka

It wasn't hard to get the boys to continue their antics for the camera. I just had to be very conscious of the shadows they were creating as they ran around trying to outdo each other for my benefit.

▲ 35mm SLR, 24-70mm lens, 1/400 f8, Ektachrome E100VS

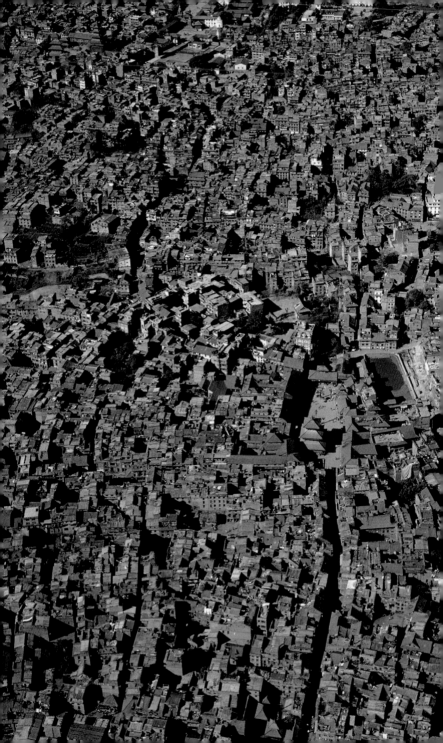

AERIALS

Take to the air for a totally different perspective on the urban environment. What can seem like a sprawling, chaotic, concrete jungle at ground level appears calm, contained and organised from above. You can clearly see the layout of the city, the relative size of the central business district to its urban sprawl, the position of landmark buildings, the green expanses of parks and sporting fields and the boundary between the urban and rural.

The most economical way up is to book a place on a sightseeing flight run by the operators of light planes, hot-air balloons and helicopters. This is a suitable option if you just want some general views of the city. However, if you want to capture particular angles or shoot at a specific height or time of day, you'll have to charter a plane or helicopter for yourself. The advantages are worth the expense, as you'll be able to remove the door for an unhindered view, work with the pilot to determine the flight path and altitude, and hover or repeat passes until you're satisfied. You'll need a minimum of 15 minutes in a helicopter if the helipad is in the city or up to an hour if the airport is on the outskirts of town. Aim for a minimum shutter speed of 1/250 but it's preferable to use 1/500 or faster to eliminate the possibility of camera shake. Be constantly aware of keeping the horizon level and building verticals straight.

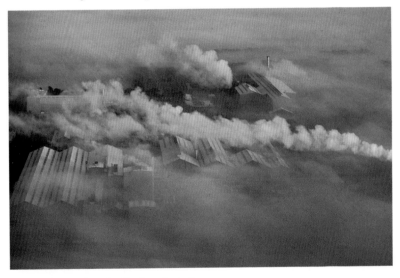

Smoke & fog over factories, Hastings, Australia
Getting airborne regularly provides unexpected photographic opportunities. We took off in clear conditions but were soon flying over an industrial area engulfed in a mixture of low-lying fog and smoke from its own chimneys, creating an unusual industrial landscape that I could never have predicted based on the weather conditions I'd experienced that morning.
▲ 35mm SLR, 50mm lens, 1/500 f4, Ektachrome E100SW

Bhaktapur, Nepal
◄ 35mm SLR, 100mm lens, 1/250 f8, Ektachrome E100SW

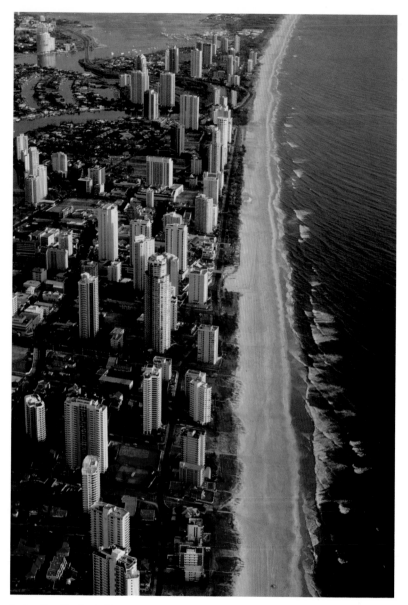

Surfers Paradise, Australia

An early-morning flight sees the high-rise and beaches of the Gold Coast bathed in a golden glow. Flying early can sometimes mean you have to work with slower than ideal shutter speeds. To minimise vibrations, don't rest any part of your body against the aircraft and keep the camera within the cabin.

▲ 6 x 7cm SLR, 105mm lens, 1/125 f4, Ektachrome E100SW

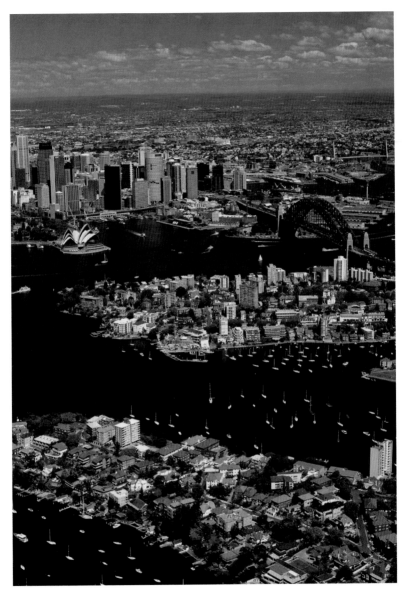

Harbour & city, Sydney, Australia

An hour in a helicopter on a perfect day over one of the world's most beautiful harbour cities remains a career highlight for me. At the time I hadn't had a lot of experience in aerial photography and it was my client who taught me that when a day is this perfect for aerials, you should stay up for as long as you can – they don't come along that often.

▲ 6 x 7cm SLR, 45mm lens, 1/500 f8, Fujichrome RDP, polarising filter

FURTHER READING

Brown, Margaret
Digital Camera Pocket Guide
Media Publishing, 2003

Burian, Peter K, and Robert Caputo
National Geographic Photography Field Guide: Secrets to Making Great Pictures
2nd edition, National Geographic, 2003

Cope, Peter
The Digital Photographer's Pocket Encyclopedia
Silver Pixel Press, 2002

Coyne, Michael
People Photography: A Guide to Taking Better Pictures
Lonely Planet Publications, 2005

Eastway, Peter
Landscape Photography: A Guide to Taking Better Pictures
Lonely Planet Publications, 2005

Elwall, Robert
Building with Light: An International History of Architectural Photography
Merrell, 2004

Evening, Martin
Adobe Photoshop CS2 for Photographers
Focal Press, 2005

I'Anson, Richard
Travel Photography: A Guide to Taking Better Pictures
2nd edition, Lonely Planet Publications, 2004

Kopelow, Gerry
How to Photograph Buildings and Interiors
3rd edition, Princeton Architectural Press, 2002

Krist, Bob
Spirit of Place: The Art of the Traveling Photographer
Amphoto Books, 2000

USEFUL WEBSITES

EQUIPMENT, FILM & SOFTWARE

Adobe Software Products
www.adobe.com

Agfa
www.agfanet.com/en

Canon
www.canon.com

Data Rescue Software
www.datarescue.com

Epson
www.epson.com

Fuji
www.fujifilm.com

Hewlett-Packard
www.hp.com

Kodak
www.kodak.com

Minolta & Konica
http://konicaminolta.com

Nikon
www.nikon.com

Olympus
www.olympus.com

Pentax
www.pentax.com

Sigma
www.sigmaphoto.com

Sony
www.sony.com

PHOTOGRAPHY: REVIEWS & RESOURCES

Digital Image Submission Criteria
www.disc-info.org

eBook
www.123di.com

DIGITAL PHOTOGRAPHY

www.betterdigitalonline.com
www.camerastore.com.au
www.dcviews.com
www.dpreview.com
www.imaging-resource.com
www.robgalbraith.com
www.steves-digicams.com

PHOTOGRAPHY & TRAVEL MAGAZINES

www.betterphotography.com
www.megapixel.net
www.nationalgeographic.com
www.outdoorphotographer.com
www.photo.net
www.photoreview.com.au
www.photosecrets.com
www.shutterbug.net

PHOTO TRAVEL GUIDES

www.phototravel.com

TRAVEL HEALTH

www.mdtravelhealth.com

INTERNET CAFÉ GUIDE

www.cybercaptive.com

LONELY PLANET

www.lonelyplanet.com

WEATHER

www.accuweather.com
www.sunrisesunset.com

INDEX

bold refers to image captions

The Travel Book

The definitive pictorial dedicated to travel and the world, The Travel Book captures every country on the planet in stunning photographs and atmospheric text. Inspirational, inviting and beautiful, it includes user-friendly A-to-Z coverage, with double-page spreads, of every country in the world.

One People

One People is a collection of glorious photographs, accompanied by thoughtful essays, that capture the universality of the human experience in the very different contexts of our diverse world. It is structured to resemble the life cycle, embracing birth, family, love, festivals and celebrations, solitude and reflection, work, home, society and death.

Rice Trails

Rice is the world's most important food but also the most fundamental. This hardcover is a beautifully conceived pictorial dedicated to everything to do with this vital food source.